IMAGES
of America

AMERICAN CHORAL
DIRECTORS ASSOCIATION

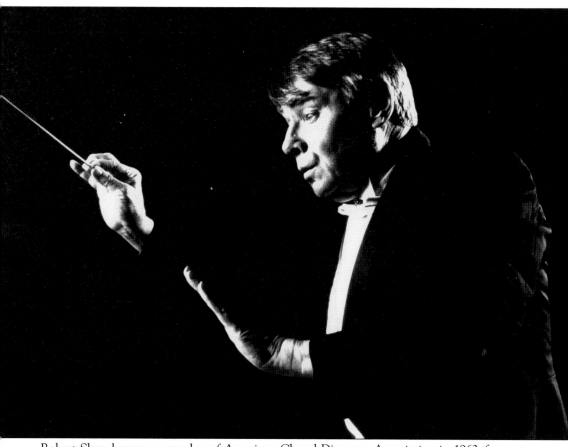

Robert Shaw became a member of American Choral Directors Association in 1963, four years after its founding, and lent his talents to the association throughout the remainder of his life. As founder of the Robert Shaw Chorale and conductor/music director of the Atlanta Symphony Orchestra and Chorus, Shaw and his choral ideals established the gold standard for choral performance in the United States in the 20th century.

IMAGES
of America

AMERICAN CHORAL DIRECTORS ASSOCIATION

Tim Sharp and Christina Prucha

ARCADIA
PUBLISHING

Published by Arcadia Publishing
Charleston SC, Chicago IL, Portsmouth NH, San Francisco CA

Printed in the United States of America

Library of Congress Catalog Card Number: 2008939198

For all general information contact Arcadia Publishing at:
Telephone 843-853-2070
Fax 843-853-0044
E-mail sales@arcadiapublishing.com
For customer service and orders:
Toll-Free 1-888-313-2665

Visit us on the Internet at www.arcadiapublishing.com

*This history of the American Choral Directors Association
is dedicated to all those who built the choral profession to its
elevated place in artistic expression, as well as to those
who aspire to excellence in the choral art.*

CONTENTS

ACKNOWLEDGMENTS

Images included in this publication are a small representation of the archival photographs and document collections housed in the American Choral Directors Association International Archives for Choral Music, which is part of the American Choral Directors Association national headquarters in Oklahoma City. Images originally appeared in issues of *Choral Journal*, the official publication of the association. Two dissertations provided much of the narrative connecting the five decades illustrated in this book. To this end, special acknowledgment is given to Ned Russell DeJournett and Craig Zamer for their comprehensive research. Further assistance was given by American Choral Directors Association charter member Curtis Hansen, former association presidents Russell Mathis and John Haberlen, and staff members Ron Granger, Jeffery Thyer, and Rachel McClain.

All documents and images were selected from the American Choral Directors Association International Archives for Choral Music.

INTRODUCTION

When the 35 choral conductors sat together in room 400 of the Municipal Auditorium in Kansas City, Missouri, in 1959, did they have any idea of the history they were making or of the remarkable organization they were founding? This group of leaders met on a cold February day to create what was to become the preeminent choral directors association in the United States. Their decisions built the foundation that shaped what was to become American Choral Directors Association (ACDA).

This founding group decided to represent all types of choirs through the work of the proposed association. As a result, today ACDA is home to children's choirs, university and college choirs, church and synagogue choirs, community choirs, and jazz and show choirs. The founders wanted to foster choral excellence, so they built conventions that encouraged and showcased this excellence through performance, reading sessions, interest sessions, and panel discussions. These elements are present in today's ACDA conventions. This founding generation, living in a time of social and political upheaval, was at the forefront of the movement in understanding the role of quality choral practice and performance. These values continue to be upheld today throughout ACDA where choirs are chosen to perform based on their quality rather than on what they represent socially or politically. These early leaders understood that American choral music must be part of a worldwide choral music movement; their international initiatives reflected this understanding. The first and foundational generation of ACDA leadership set a high bar for its members, and subsequent generations have honored and raised that bar.

In the early 1970s, leadership transferred hands from one generation to the next. The second generation of ACDA grew the organization and gave it independence and a broader voice. This group of individuals created independent divisions, resulting in divisional as well as national conventions. These leaders began to invite international groups and world renowned conductors to perform, teach, and conduct. This new generation elevated the standards for convention performance by choosing premier concert halls for performance. It understood that funding for the arts and arts advocacy is important and must be a hallmark of ACDA. To that end, it created the advocacy statement that is still evoked in each issue of *Choral Journal*.

The second generation of ACDA leadership never forgot the lessons of the first. It expanded the ideas of its teachers and mentors. It created a solidly academic *Choral Journal*; it refined a choral conducting and research curriculum throughout America's colleges and universities; it established policies and procedures for choral repertoire and standards; and it set out on an educational and performance agenda that gave solid direction to choral conducting students, leading to even stronger directors and academicians. It gave opportunities to youth and college

students to sing under the direction of the world's greatest choral directors. It provided many opportunities for choir directors to observe and learn the best in choral arts practice through workshops and conventions. This generation understood the mission of the founders and used that foundation to adhere to and deepen those values.

As ACDA entered the 21st century, legendary status was conveyed to the founding members and the noted choral educators, writers, researchers, and conductors who built ACDA. The choral art had earned its place alongside the most revered of the classical art forms. With the death of Robert Shaw in 1999, ACDA said goodbye to its first truly marquee choral conductor who infused professionals with the enthusiasm of amateurs, and amateurs with the skills of professionals. His magic was more spiritual than technical, and he became a patron saint for choral conductors in the United States.

The ACDA leadership that had professionalized and energized choral music education and performance, and that had established the highest standards of practice, had now passed the baton, literally, to a new generation of choral scholars, teachers, and performers. This new generation can be found engaging in a grassroots effort to increase membership. It is reaching out to members and nonmembers alike in states and divisions to spread the purposes of ACDA and inspire yet another generation to aspire to excel in the choral arts.

This new generation of ACDA choral directors now enters the 21st century connected to a world performance arena influenced by choral sounds from around the globe. Today ACDA realizes more fully the prophetic international intentions of its founders by the inclusion of international choirs at its conventions and its leadership in the International Federation for Choral Music (IFCM). The choral program exchanges of the 1950s now take place digitally through cataloged video choral performances and concerts observed through real-time streaming video. Printed journals and newsletters are now accompanied by ever-emerging, ever-updated searchable digital media. Discussions are shared worldwide through Listservs, blogs, and other electronic outlets. Choral tonal models have moved beyond provincial homogeneity to a world palate of vocal sound.

In 2009, ACDA celebrated its 50th anniversary as a professional choral association, the largest of its kind in the world. Thousands of choral professionals continue to gather in celebration of the choral art in biennial conferences, and with the 50th anniversary convention in Oklahoma City, a very short distance from where the movement began in Enid, Oklahoma, in the mid-1950s. Once again, a wide variety of choir types, representing the best choral music making in the United States and around the world, perform for one another and for the world's choral leaders. They come together primarily for the inspiration that comes from the sounds that they have mastered in their home settings. It is hard to determine if inspiration comes most from giving or from receiving these sounds.

ACDA's new face and new voice is international, multicultural, and technological, and it inherits a legacy and a soul that is inspirational, professional, and totally enamored by the choral art. We will forever be the only directors of a musical art form that is able to deliver a text to an audience through harmony by a living community of vocal artists. We will forever strive to deliver those sounds in a clearer and more perfect voice. ACDA was created to help us with this task.

One

THE FOUNDATION

Throughout the decade that preceded the founding of the American Choral Directors Association (ACDA), whenever choral directors gathered to do their work, discussions took place about the organization of a national choral association specifically for choral conductors. The idea for what would become ACDA gathered steam during the early 1950s, but real progress was made during the years 1955 and 1956 at the Tri-State Music Festival in Enid, Oklahoma, when Archie Jones, director of choral music at the University of Texas, and Robert L. Landers, director of the United States Air Force Singing Sergeants, were together as clinicians and judges at this annual choral event.

Archie Jones stated in a letter dated March 4, 1970, "During the summer of 1957 I had Harry Wilson come to the University of Texas for a choral clinic. [Wilson was a professor of music education at Columbia University.] One of the evenings I took Harry out to my cottage about twenty miles from Austin for a 'cook-out.' After dinner we sat around . . . discussing choral music in general. I suggested that we needed a choral organization paralleling the American Bandmasters Association. Harry was so receptive to the idea that we decided to go ahead with the idea."

Bolling 25, D. C.
December 2, 1957.

Mr. R. Wayne Hugoboom
Marshall College
Huntington, West Virginia

Dear Mr. Hugoboom,

This letter is going to 100 choral directors throughout the nation, most of them in colleges, but some also in churches and high schools. The purpose is to ascertain your interest in a proposal.

For several years the undersigned gentlemen have discussed, among themselves, and with many of you, the feasibility and desirability of an organization of choir directors paralleling the American Bandmasters' Association, and called, for the present at least, the American Choirmasters' Association. We propose to limit membership, at present, to 175.

We are proposing that this organization be honorary, that it exercise similar functions to the ABA, that it hold an annual convention, and write its constitution and *by-laws in conformance, with exceptions, to those of the ABA.

We think it unnecessary to outline the many advantages of such an organization, since such a movement has been discussed quite generally in recent years.

The tentative plan of organization is that the three undersigned will act as an executive committee until officers are elected at the first convention, and that the three be increased to eleven, for the purpose of constituting a more representative steering committee, during the process of organization. Incidentally, the dues of the ABA are $10.00 per year, just so you will have all the facts at hand.

If you are interested, will you please write a card or letter to Captain Robert L. Landers, U. S. Air Force Band, Bolling 25, D. C. referring, for convenience, to the following numbers:

1. Your interest in becoming a charter member;
2. Names of your nominees for the steering committee;
3. Names of choirmasters who should be included as charter members;
4. Your choice of approximate dates and place for first convention;
5. Any suggestions you may have.

If we do not hear from you promptly, we shall conclude that you are not interested.

Cordially,

Robert L. Landers

Archie N. Jones
University of Texas

Maynard Klein
University of Michigan

RLL;rlh

In 1957, Archie Jones, Raymond Rhea, and Warner Imig continued the conversation regarding the formation of a professional association and were joined by Earl Willhoite and Roger Wagner in the growing interest toward a national choral organization. This gathering interest took place at choral clinics as networking continued. On December 2, 1957, Robert L. Landers sent a letter to 100 choral directors selected by Jones, Maynard Klein, and Landers. In the letter, he outlined a plan to establish an American choirmasters association, which would function as a 175-member honorary choral directors organization to be patterned after the American Bandmasters Association. Landers's letter proposed that he, Jones, and Klein function as the executive committee of the new association until a committee could be elected. The letter further proposed that these three be joined by eight others who would form the charter membership that would establish a steering committee for the operation and planning of the association.

With the penning of Robert L. Landers's letter, ACDA was formed. Commenting on this action, Elwood Keister, director of choral activities at the University of Florida, stated, "We had all done a lot of thinking about it, but we had never taken the initiative. The impetus came from the man who wrote the first letter saying 'why don't we get together and organize.'" Prior to the formation of a steering committee, Archie Jones stated, "We need a set of purposes, a much larger membership list, and some decisions as to the qualifications of new members—in short, all of the thinking that needs must go into a new organization." Jones's challenge led to the expansion of the list of charter members, the consideration of establishing a relationship with an already established professional organization, the drafting of an outline for a constitution and set of bylaws, the determination of organizational function, and the planning of the initial meeting of the association.

Dec. 16, 1957

Capt. Robert L. Landers,
U. S. Air Force Band,
Bolling 25, D. C.

Dear Capt. Landers:

In reply to your letter of Dec. 2, 1957, regarding the
formation of the American Choirmaster's Association, let
me say that I am completely in favor of its formation.
My answers to your numbered questions are as follows:

1. I would be happy to be one of the charter members.

2. My nominees for the steering committee in addition to
 the original three include L. N. Perkins, Oklahoma State
 University, Stillwater, Okla; Warner Imig, Colorado U.,
 Boulder, Colorado; Dr. Charles Hirt, USC, Los Angeles,
 California; Dallas Draper, Louisiana State U., Baton Rouge,
 La.

3. Names of choirmasters to be included as charter members
 are: Ed Hatchett, San Benito High School, San Benito, Texas;
 Gene Kenney, Texas Tech, Lubbock, Texas; Lee Fiser, North-
 eastern Louisiana College, Monroe, La.; Dr. Jack Juergens,
 Southwestern College, Winfield, Kansas; Alvis Autrey, McAllen
 High School, McAllen, Texas; Charles Nelson, Edinburg High
 School, Edinburg, Texas; Ira Bowles, Southwest Texas State
 College, San Marcos, Texas; M. F. Johnstone, Abilene High
 School, Abilene, Texas.

4. My suggestion as to dates of the convention is to have
 it in connection with one of the major music conventions
 next year. That would give the steering committee time
 to meet, organize, and prepare for the first convention.

I am happy to know that you are taking some definite action
to organize such a group. If there is anything else I can
do please call on me.

 Very sincerely,

 Frank McKinley

 Frank McKinley,
 Choral Director

Following the mailing of Landers's December 2, 1957, letter, 34 of the 58 recipients replied. Most of the responses were positive and several of the respondents suggested that the meeting of the new organization take place in conjunction with another national organization that was compatible with the work of academic choral directors, including organizations such as the National Association of Teachers of Singing (NATS), the Music Teachers National Association (MTNA), or the Music Educators National Conference (MENC).

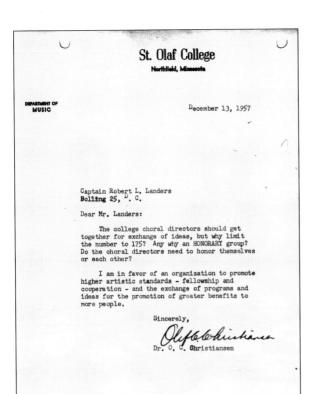

St. Olaf College

Northfield, Minnesota

DEPARTMENT OF
MUSIC

December 13, 1957

Captain Robert L. Landers
Bolling 25, D. C.

Dear Mr. Landers:

The college choral directors should get
together for exchange of ideas, but why limit
the number to 175? Any why an HONORARY group?
Do the choral directors need to honor themselves
or each other?

I am in favor of an organization to promote
higher artistic standards - fellowship and
cooperation - and the exchange of programs and
ideas for the promotion of greater benefits to
more people.

Sincerely,

Dr. O. C. Christiansen

The founding members were conscious that the new organization should not favor one group or choir type over another. Olaf Christiansen's reply to Robert L. Landers's letter summarizes this sentiment and sets the foundation for ACDA's commitment to promoting and disseminating the very best in choral conducting and performance practices for choirs of all types. Christiansen explicitly stated in the letter his belief that ACDA not be reserved only for college and university choral directors; the organization needed to be accessible to qualified conductors, regardless of the type of choir they conducted.

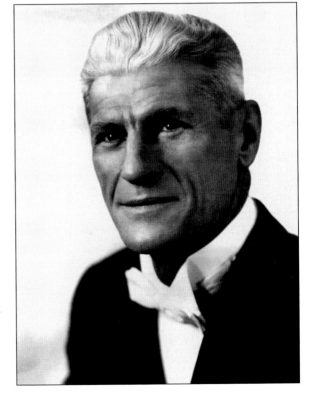

Olaf Christiansen was conductor of the St. Olaf Lutheran Choir and a charter member of ACDA. He continued the pioneering choral work of his father (F. Melius Christiansen) in the United States and together established the family name and reputation as a household synonym for superior choral music practice.

Robert Shaw was one of the recipients of Landers's letter of invitation. His response was guarded, stating that he was not familiar with the American Bandmasters Association. He joined in 1963 and in 1997 had this to say about ACDA: "In the very early years of its four decades, I was not among its most enthusiastic supporters or founding fathers . . . Though it is rare indeed, bigger, apparently and occasionally, can be better. It appears now that I was wrong way back when."

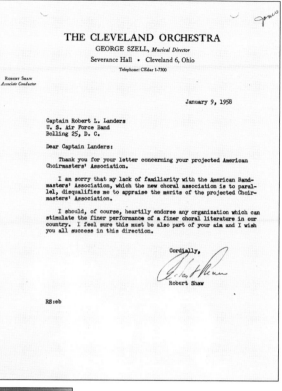

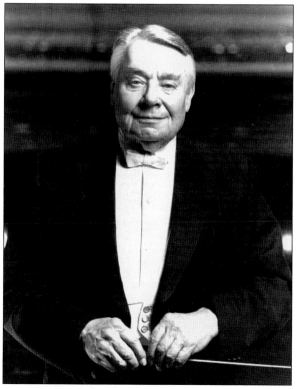

Robert Shaw first garnered national attention upon founding the Robert Shaw Chorale in 1949. He was named music director of the San Diego Symphony in 1953, serving four years. He took over the Cleveland Orchestra Chorus and fine-tuned it into one of the finest all-volunteer choral ensembles. From 1967 to 1988, he was conductor of the Atlanta Symphony Orchestra. Shaw conducted numerous choirs at ACDA conventions. ACDA dedicated the featured performance of Brahms's *Ein Deutsches Requiem* at the 1999 ACDA National Convention in Chicago to Shaw.

UNIVERSITY OF SOUTHERN CALIFORNIA
SCHOOL OF MUSIC
UNIVERSITY PARK
LOS ANGELES 7

March 10, 1958

Capt. Robert Landers
U.S. Air Force Band
Bolling 25, D.C.

Dear Capt. Landers:

Thank you for your letter of March 3rd. As I stated in my previous
letter, I shall be delighted to serve with you on the Steering
Committee of the American Choirmaster's Association.

March 23rd at 12:30, however, is not a good time for me. This
coincides with the final rehearsal for the MENC All-Conference Chorus
which I will direct in performance that evening in Shrine Auditorium.

I shall look forward to seeing you at the Convention. Kindest regards
and best wishes for success in this important endeavor.

Sincerely yours,

Charles C. Hirt, Head
Church Music and
Choral Organizations

CCH/pm

The first steering committee consisted of the following members: Robert L. Landers, United States Air Force; Archie Jones, University of Texas; Charles C. Hirt, University of Southern California; Harry Robert Wilson, Teachers College, Columbia University; Warner Imig, University of Colorado; Elwood Keister, University of Florida; Earl Willhoite, Fred Waring Workshop; Peter Wilhousky, board of education, New York City schools; John Raymond, Lafayette College; Maynard Klein, University of Michigan; R. Wayne Hugoboom, Marshall College; and James Aliferis, University of Minnesota. It was suggested in the first letter to this group that a meeting be held on Sunday, March 23, 1958, at the MENC convention meeting in Los Angeles, California. The 11-member steering committee ultimately consisted of Archie Jones, Robert L. Landers, Charles C. Hirt, Harry Robert Wilson, Warner Imig, Elwood Keister, Earl Willhoite, John Raymond, R. Wayne Hugoboom, Roger Wagner, and James Aliferis. Four members of this group indicated they would not be able to attend the Los Angeles meeting. Therefore, a meeting was not held and the group conducted business by correspondence.

ARKANSAS STATE COLLEGE
STATE COLLEGE, ARKANSAS

March 24, 1958

DEPARTMENT OF FINE ARTS

Dr. Archie N. Jones
Department of Music
The University of Texas
Austin 12, Texas

Dear Archie:

It is urgent that we follow up quickly on your idea of a College Choir Directors
Organization. The pilot study of such a group in the West Central Division leads
me to feel that the time is ripe for us to launch this. What is your thinking
from this point on? Would you be interested in first setting up a special committe
in MTNA, and after the organization gets under way, establishing the national
status on an affiliated basis? I will guarantee MTNA's support. The main thing is
immediate action. If you don't want to carry the ball as chairman, would you
consider letting me submit a name? I know someone whis is more than interested.

Best wishes,

Duane H. Haskell
President-MTNA

By the end of May 1958, the number of ACDA charter members reached 100, and by February 1959, the charter membership numbered 134. At this membership level, the new body began to think about the desire for meeting together as a new organization. The charter members thought that if this new group, the American Choirmasters Association, combined with another professional organization such as MENC, MTNA, or NATS, this would facilitate a more successful initial gathering. Contacts were made to MENC and MTNA for this purpose. An enthusiastic response came from Duane Haskell, president of MTNA. He offered the fledgling group a special committee through MTNA and affiliated status when the group was formally established.

17

THE UNIVERSITY OF TEXAS
THE COLLEGE OF FINE ARTS
AUSTIN 12

DEPARTMENT OF MUSIC

April 15, 1958

Dear Colleague:

The American Choirmasters Association is in the process of formation! It has progressed so far as to have a Steering Committee and just short of 100 Charter members. From recent correspondence, we have derived your name, among a few others, and this letter is to inquire as to whether or not you would be interested in becoming a Charter member?

The plan is to form an organization somewhat parallel to the American Bandmasters Association, attach ourselves to one of the major organizations such as MTNA, and hold annual conventions. The first meeting is projected in conjunction with the MTNA convention in Kansas City next February.

The Steering Committee at present is as follows:

Captain Robert Landers, U. S. Air Force Band, Washington 25, D.C.
Dr. Charles Hirt, University of Southern California, Los Angeles, California
Dr. Harry Wilson, Columbia University, New York, New York
Dr. Elwood Keister, University of Florida, Gainesville, Florida
Dr. Earl Willhoite, Waring Workshop, Delaware Water Gap, Pa.
Dr. John Raymond, Lafayette College, Easton, Pa.
Mr. Wayne Hugoboom, Marshall College, Huntington, West Va.

and the undersigned. We are presently working on such items as Constitution and By-Laws, membership, purposes, and functions. All of these matters will be reviewed at the first meeting.

Will you please indicate your interest, in which case your name will be added to the mailing list and Charter membership.

In your reply, you might also list others whom you think should be included. It is not intended that membership should be limited to College people, but to include church and outstanding high school directors.

Cordially,

Archie N. Jones
Professor of Music

ANJ:vm

Responses to Robert L. Landers's letter yielded names of many choral conductors, 69 of whom Archie Jones and Landers considered qualified for charter membership. A letter of invitation to charter members and a description of the projected organization were sent to each of these persons on April 15, 1958. These 69 prospective members were asked to list others whom they considered qualified for membership. Jones emphasized that memberships should not be limited to college directors but should include outstanding church and high school conductors.

18

It was proposed that the embryonic ACDA study the American Bandmasters Association and the College Band Directors Association as foundational elements for its constitution. Harry Robert Wilson volunteered to write a set of organizational purposes that would be incorporated into the body of the constitution. This photograph of Wilson was taken as he conducted the convention chorus at the California Music Educators Conference in San Mateo in 1964.

Jones

MILLS MUSIC, INC.

JACK MILLS
PRESIDENT

Music Publishers

1619 BROADWAY, NEW YORK 19, N. Y.

COLUMBUS 5-6350-1-2-3-4
CABLE: MILLSMUSIC, N. Y.

April 23, 1958

Dr. Archie N. Jones
Professor of Music
The University of Texas
Austin 12, Texas

Dear Archie:

I will be interested in The American Choirmasters Association.
Please keep me on the mailing list for future information on
the Organization.

If the name has not yet been incorporated I suggest that some
thought be given to the use of the word "Choirmaster". Will
this term imply that the association is open only to church
musicians. The term usually implies direction of a church
choir.

I suppose you have considered other possible names such as the
Choir Directors of America, The American Choral Association, etc.

In any event, please keep me posted, I am interested.

Cordially,

MILLS MUSIC, INC.

Don Malin
Educational Director

DM:ns

MILLS MUSIC, INC.	MILLS MUSIC, INC.	MILLS MUSIC, INC.	MILLS MUSIC, LTD.	EDITIONS MILLS MUSIC, BELGIUM
64 East Jackson Boulevard,	6533 Hollywood Boulevard,	411 West Seventh Street,	20 Denmark Street,	13 Rue de la Madeleine,
Chicago 4, Ill.	Hollywood 28, Calif.	Los Angeles 14, Calif.	London, W.C.2. England	Brussels, Belgium

Don Malin, of Mills Music, suggested in a letter dated April 23, 1958, that the new organization be called the Choir Directors of America or the American Choral Association. Elwood Keister offered the name American Choral Directors Association in May 1958. It had been the opinion of the steering committee that the name American Choirmasters Association continue to function unofficially until a membership vote could be taken at the first meeting of the association.

Before the vote on the naming of the association at the February 1959 meeting, others had voiced their dislike of the name American Choirmasters Association. Helen Hosmer from the Crane School of Music summed up the general feeling indicated at the organizational meeting nearly a year earlier with her letter stating, "The name to me signifies church music rather than college and high school choral directors."

The name for the association was the first matter of business at the organizational meeting in Kansas City, Missouri. The working title of the association was the American Choirmasters Association. Echoing the sentiments of Helen Hosmer, the consensus of the charter members was that the word *choirmasters* had the specific reference to church choral directors, and the name should be broader. Robert Mitchum, of Wabash College, motioned that the name be the American Choral Directors Association. The motion carried and ACDA was born.

May 30, 1958

Mr. Wayne Hugoboom, Marshall College, Huntington, West Virginia
Dr. Warner Imig, University of Colorado, Boulder, Colorado
Dr. Elwood Keister, University of Florida, Gainesville, Florida ✓

Gentlemen:

The American Choirmasters Association is off the ground. Our 100th charter member came in today! About evenly divided between college, high school, and church choir directors. Perhaps a few more college people.

I am suggesting that we meet one full day in advance of the MTNA Convention in Kansas City (MTNA is February 24-28, 1959) to organize, establish the Constitution and By-Laws, elect officers, etc., and then schedule several meetings as part of the program of MTNA, a general session (Earl, do you think Waring would come to make the speech at the general session at his own expense?), and several sectional meetings devoted to reading through numerous octavo.

I am also suggesting that the three to whom this letter is addressed act as a pre-selection committee to screen octavo for reading at the Convention. My plan is to have the publishers send you three gentlemen single copies of things they want to recommend, ask you three to select from what they send, the titles you want read at the Convention. You would then send me the copies (or titles) you recommend, and I will ask the publishers to send (through one of the local stores in Kansas City) a sufficient number of copies for the group to read.

Any other program suggestions will be welcome. July 1 is the deadline for MTNA program copy. We can decide on February 23 whether or not to affiliate with MTNA.

Now:

1. Will Hugoboom, Imig, and Keister please let me know if they are willing?

2. Will all of you please write your suggestions and/or approval.

Cordially,

Archie

Archie N. Jones
Professor of Music

ANJ/pyb
CC8: To the other members of the Steering Committee.
P. S. Within a short time I will send you a copy of the charter membership list.

The charter members of the association were advised of the organizational meeting plans by two letters. The first letter indicated the meeting would take place on Monday, February 23, 1959, at the MTNA convention in Kansas City, Missouri. At this time, the steering committee was in place and the organizational event began to take place.

AMERICAN CHOIRMASTER'S ASSOCIATION

meeting with

Music Teachers National Association

Muehlebach Hotel, Kansas City, Mo.

February 24 - 28, 1959

Dear A. C. A. Member:

The plans for our first Convention are shaping up nicely. The schedule of A. C. A. meetings is as follows:

Tuesday, February 24, 1959

9:00 A. M. Organizational meeting, Room 400
1:30 P. M. Symposium: "The Place of Choral Music in American Life", Gene Hemmle, Chairman; Clayton Krehbiel, Moderator. Followed by a Reading Session, Room 400.
3:30 P. M. Joint meeting with School Music Section, M. T. N. A., Panel Discussion: "Improving Standards of Music for Performing Groups", Harton Zahrt, Moderator.

Wednesday, February 25, 1959

4:00 P. M. Reading Session, Room 403

Thursday, February 26, 1959

8:45 A. M. Reading Session, Room 403
2:00 P. M. Reading Session, Room 403

This program has been arranged to coordinate with the M. T. N. A. programs, so that those of you who wish to do so may attend most of the M. T. N. A. functions.

Your Steering Committee has adopted, subject to approval or rejection at the business meeting, the magazine "The Choralear". You will receive a copy soon.

Enclosed is a brief first draft of a "trial" Constitution and by-laws. Please come to the Convention prepared to suggest deletions, additions, or changes. Meanwhile, I would be happy to hear from you regarding this, so that it might be as complete as possible when we meet.

Cordially,

Archie N. Jones

Archie N. Jones

A second letter announced the schedule of events for the meeting. With that schedule of events, Archie Jones issued trial copies of a constitution and bylaws to the charter members. These were to be studied and debated prior to the organizational meeting in February 1959. In addition, the emerging association adopted two projects—the convening of the association at a national convention to be held in conjunction with another major association and the operation of a choral program exchange. The inaugural February meeting in Kansas City, Missouri, included a choral reading session, a feature of ACDA conventions that has endured through the years.

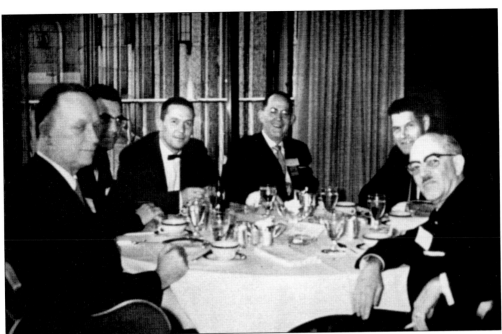

By the time of the organizational meeting, at least one other member had joined the final steering committee list. Curtis Hansen, a high school teacher from Brainerd, Minnesota, was the only high school teacher to be on the steering committee. Above are members of the steering committee at the organizational meeting in Kansas City, Missouri. From left to right are J. Clark Rhodes, Elwood Keister, Curtis Hansen, Harry Robert Wilson, R. Wayne Hugoboom, and Archie Jones. Warner Imig, another steering committee member, took the picture.

On Tuesday, February 24, 1959, at 9:00 a.m., 35 choral directors assembled in room 400 of the Kansas City, Missouri, Municipal Auditorium to establish ACDA. The proceedings of the meeting included the adoption of a constitution and bylaws, election of officers, establishment of dues, authorization of the new choral program exchange, determination of the date and location of the association's next meeting, discussion of the association's official publication, and a debate regarding organizational affiliations.

WILSON CHAIRMAN OF THE CONSTITUTION ADOPTION COMMITTEE ON
PURPOSES.

MR. WILSON SUGGESTED THAT THE PURPOSES COULD BEST BE
CLARIFIED AND ADOPTED BY READING, DISCUSSING AND REVISING
EACH IN TURN. THE REMAINING PORTION OF THE MORNING SESSION
WAS CONCERNED WITH THE PURPOSES OF ACDA.

BY 12 NOON, ARTICLES I AND II OF THE CONSTITUTION HAD BEEN
ADOPTED. THE CHAIRMAN REMINDED THE GROUP THE NEXT MEETING WAS
SCHEDULED FOR 1:30 P.M., BEFORE ADJOURNING THE SESSION.

TUESDAY, FEBRUARY 24, 1959, 1:30 P.M.

THE ACDA RECONVENED AT 1:30 P.M. IN ROOM 400 OF THE KANSAS
CITY MUNICIPAL AUDITORIUM.

TEMPORARY CHAIRMAN ARCHIE JONES ASKED FOR THE REPORT OF
THE NOMINATING COMMITTEE. MR. WM. BOLAND SUBMITTED THIS SLATE
OF NOMINEES:

FOR PRESIDENT , ARCHIE N. JONES

FOR VICE-PRESIDENT, ELWOOD KEISTER

FOR SECRETARY-TREASURER, EARL WILLHOITE

FOR MEMBERS-AT-LARGE

1. R. WAYNE HUGOBOOM 1959
2. HARRY R. WILSON
3. WARNER IMIG

AND MOVED THAT THE REPORT BE ACCEPTED AND THAT THE NOMINEES
BE ELECTED BY ACCLAMATION. THE MOTION WAS SECONDED AND ADOPTED
BY A VOICE VOTE.

PRESIDENT JONES READ A LETTER FROM ALLEN CORNWALL, EDITOR

A nominating committee headed by William V. Boland of Midwestern University submitted the following nominees to the membership: president, Archie Jones; vice president, Elwood Keister; secretary-treasurer, Earl Willhoite; and board members, R. Wayne Hugoboom, Harry Robert Wilson, and Warner Imig. This slate was accepted by acclamation.

Choral Directors

AMERICAN ~~CHOIRMASTERS~~ ASSOCIATION CONSTITUTION *gous*

ARTICLE I

is
~~NAME~~. The organization, ~~shall be known as~~ the American ~~Choirmasters Association~~. *Choral Directors*

ARTICLE II

PURPOSES. 1. To foster and promote the use of choral singing to provide artistic and spritual experiences for the participants.
2. To foster and promote the use of the finest type of choral music to make these artistic and spiritual experiences possible.
3. To foster and encourage rehearsal procedures conducive to attaining the highest level possible in artistic performance.
4. To foster and promote the organization and development of choral groups of all types in schools, colleges, and churches.
5. To foster and promote the organization and development of amateur choral societies in cities and communities.
6. To cooperate with all organizations dedicated to the development of musical culture in America.
7. To disseminate professional news and information among the members.
8. To contribute to intelligent understanding of choral music as an important medium of musical art.
9. To evaluate new issues of choral music and recommend worthy titles to the membership.
10. To attain the dream of a "singing America" through artistic choral singing.

ARTICLE III *director*

MEMBERSHIP. Section 1. Classification of membership shall be (a) Active, (b) Associate, (c) Honorary, and ~~(d) Student~~.
Section 2. To be eligible for Active membership, the candidate must be active ~~conductors~~ of college, church, or high school, ~~choirs, either on full or part time basis~~. Charter members are hereby declared active members, regardless of their professional status, and shall be hereafter entitled to that classification, subject only to provisions of the by-laws.
Active membership requirements presuppose a ~~fair~~ knowledge of musical theory, choral arranging, score reading, recognized ability as a choral *director* ~~conductor~~, and a high standard of professional ethics.
Section 3. ~~Associate members shall be elected in the same manner as Active members~~, shall not hold office, shall not have vote, but shall have all other ~~privileges~~ accorded Active members. Any publisher of choral music, or manufacturer of choral accessories, or other person or firm directly interested in the furtherance of choral ~~performance~~ may ~~be invited to~~ become an associate member ~~but~~
Section 4. Honorary members shall be elected by majority vote at any national convention, shall not hold office nor vote, but shall have all other privileges accorded Active members.

Associate members may be: A. Publishers of choral music ... or dealer in ... B. Any firm ... or patron ... interested ...
manufacturers, acc.
C. Any individual interested in choral music — —

Harry Robert Wilson authored ACDA's statement of purposes and was appointed chair for the Constitutional Adoption Committee on Purposes. The entire assembly served as the committee for the developing constitution. Ten purposes framed the discussion: to foster and promote choral singing with artistic and spiritual experiences for the participants; to foster and promote the finest types of choral music to make these experiences possible; to foster and encourage rehearsal procedures conducive to attaining the highest level possible in musicianship and artistic performance; to foster and promote the organization and development of choral programs of all types in schools, colleges, and churches; to foster and promote the organization and development of choral societies in cities and communities; to foster and promote the intelligent understanding of choral music as an important medium of artistic expression; to foster and promote research in the field of choral music; to foster and support composition of superior quality in both music and text for all choral combinations; to cooperate with all organizations dedicated to the development of musical culture in America; and to disseminate professional news and information about choral music.

AMERICAN CHORAL DIRECTORS ASSOCIATION

Attached is your 1959 Membership Card which indicates that your application membership has been approved and 1959 dues are paid.

Organized this year to promote better relationships and cooperation among Colle High School and Church Choral Directors to further good choral music, A.C.D.A. is happy to welcome you as a member. Talk to your friends about the Association and take an active part in enrolling members.

Address all inquiries to Dr. Earl Willhoite, Sec'y-Treas., Fred Waring Music Workshop, Delaware Water Gap, Pennsylvania.

American Choral Directors Associatio

This is to certify that

is a Member of this association
in good standing for the current year

MEMBER'S SIGNATURE

1959

Carl Willhoi
Secretary-Treasur

The majority of those attending the Kansas City meeting agreed that future membership to the association be effected through a sponsor, rather than by honorary membership. A sponsored membership policy, by which a prospective member would be sponsored by an active member, would allow for selectivity without impeding organizational growth. The policy was in place until the 1973 constitution and bylaws revision. Those joining in 1959 received the card above once they had paid their $6 dues.

A rather subtle purpose of the association was signaled in the work of a choral program exchange that was initiated at the original meeting. This involved each member bringing 200 choral programs (printed copies) that were shared with the group for the purpose of idea and literature exchange. This early example of professional networking would become a central purpose of ACDA over the years. This would also become ACDA's first official service project, led by Elwood Keister. The activity was sanctioned and a committee was established for its continuation. Above is the booklet for the 1964–1965 choral program exchange.

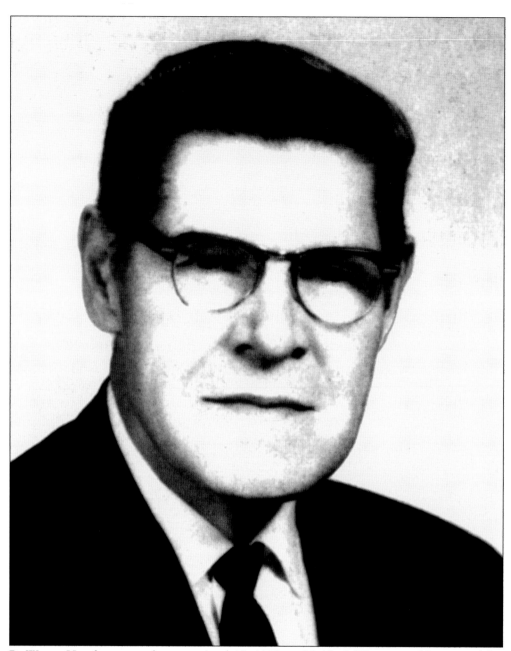

R. Wayne Hugoboom was born on April 13, 1907, in Medford, Wisconsin. He received his bachelor degree in music and master of arts degree from the University of Wisconsin. After serving in the military during World War II, he headed the choral program at Indiana University from 1946 to 1948. In 1950, he became the head of the choral department at Marshall University in Huntington, West Virginia. In 1958, he was appointed head of the music department at Manatee Junior College in Bradenton, Florida. He became a founding board member for ACDA in 1959 and also edited the *Choral Journal*, which he continued to edit throughout his service to ACDA. He became ACDA's first executive secretary (executive director) in 1964 and served in this capacity until his death in 1977.

Two

THE ASSOCIATION

Harry Robert Wilson was asked
to prepare material for a bulletin
that would be printed under the
supervision of R. Wayne Hugoboom
and mailed to the charter members
and other choral directors
suggested by secretary-treasurer
Earl Willhoite. This bulletin, the
Choral Journal, eventually evolved
into ACDA's official professional
periodical, *Choral Journal*.

The Choral Journal

MAY 1959 Official Bulletin of the American Choral Directors Association NO. 1

President's Letter

On Tuesday, February 24, 1959, an historic meeting took place in Kansas City, Missouri, in connection with the biennial national convention of the Music Teachers National Association. The meeting: the organizational meeting of the American Choral Directors Association.

During the course of 1958, a Steering Committee was organized by mail. Each member suggested a list of names of choral directors who were considered competent, and sufficiently interested in the profession to support an organization. The Steering Committee early recognized the fact that although every other facet of the music business and profession was represented by an organization, no such representation existed on a national level for choral directors!

As soon as names were suggested by the Steering Committee, descriptive letters were sent, again asking for other names. It was decided that the first, or organizational, meeting would take place in conjunction with the M.T.N.A. convention, this being the best available major vocational convention centrally located.

Of the one hundred thirty directors accepting charter membership, more than seventy attended the organizational meeting. A constitution and by-laws were adopted, officers elected, and after the first business meeting the members participated in four choral reading sessions. The music was pre-selected by a committee of three, and sent at their own expense by the publishers. The music was packaged and distributed without charge by the Jenkins Music Company of Kansas City.

The American Choral Directors Association is now an established organization. A list of the purposes appears elsewhere in this News Letter, as does an application for membership. The next annual convention will be held in Atlantic City in March of 1960, at which time numerous program features will be combined with reading sessions. These will be channeled to the interest of the four categories of membership: college, high school, church, and industry.

Archie Jones

ARCHIE N. JONES
President ACDA

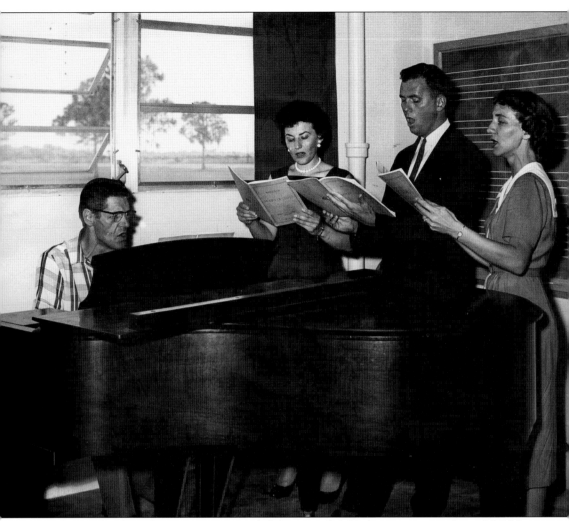

The newly adopted constitution provided for annual ACDA conventions. Since MTNA was functioning on a biennial conference schedule, a 1960 MTNA-ACDA national conference was not possible. The suggestion was made that the 1960 ACDA conference be held in conjunction with the MENC national convention, convening in March 1960, in Atlantic City, New Jersey. President Archie Jones indicated that notification of the exact date and location of the ACDA convention would be made at a future date. The date was eventually set for March 16–17, 1960, and R. Wayne Hugoboom agreed to serve as program chair. Pictured in 1960 are, from left to right, R. Wayne Hugoboom, pianist, Marie Montaldi, contralto, David Robinson, tenor, and Mrs. Don. A. Ripley, soprano.

The Choral Journal

JANUARY 1960 Official Bulletin of the American Choral Directors Association NO. 2

President's Letter

ARCHIE N. JONES
President ACDA

Dear Colleagues:

The American Choral Directors Association will hold its first annual convention in connection with the Music Educators National Conference convention, two days preceding the MENC opening session. Remember the dates, March 16-17, 1960, in Atlantic City, Ambassador Hotel.

An excellent program has been prepared by Program Chairman Wayne Hugoboom, ably assisted by board member Harry Wilson. An outline of this program is contained elsewhere herein.

During the first year of our existence, ACDA has "made haste slowly", but with this important convention taking shape, great strides in membership and projects are anticipated.

Contained also in this brochure is an application blank. Feel free to write any member of the Board of Directors to sponsor your application. If the board members are unknown to you, simply mention a few people who could act as your sponsors. The sponsor idea is not intended to exclude anyone.

We believe that there is a real need for ACDA in music circles, and we have a strong desire to fulfill our purposes.

See you in Atlantic City.

Cordially,

Archie N. Jones

ANNOUNCING THE
A. C. D. A. National Conference For 1960
(under the aegis of M. E. N. C.)

March 16-17 ATLANTIC CITY, N. J. Ambassador Hotel

A Conference devoted solely to the interests of College, Church, High School and Industrial Choral Directors, the sessions offer concerts, lectures, demonstrations, discussions and reading sessions by national and international musicians in a packed two-day program designed to interest all members and visitors, and arranged so all may attend ACDA and MENC, March 18-22, at the Atlantic City Municipal Auditorium, a 5-minute walk from the Ambassador.

Read the Complete Program for ACDA on Pages 4 and 5
Make Your Reservations NOW
Write direct or use Reservation Forms in MENC Journal

The next convention was planned to take place in conjunction with the MENC meeting in Atlantic City, New Jersey, in March 1960. An announcement appearing in *Choral Journal* advertised the meeting: "A Conference devoted solely to the interests of College, Church, High School and Industrial Choral Directors, the sessions offer concerts, lectures, demonstrations, discussions and reading sessions by national and international musicians in a packed two-day program designed to interest all members and visitors, and arranged so all may attend ACDA and MENC, March 18-22, at the Atlantic City Municipal Auditorium."

31

In 1960, ACDA was an unknown entity, so it was with great courage that the first five choruses sang at the convention. Their effort set the precedent for choral excellence that remains a hallmark of ACDA conventions. Elaine Brown's Singing City Choir from Philadelphia was one of the original convention choirs at the 1960 event. Born out of the Fellowship House movement, Singing City sought to bring people of various races, religions, and cultures together through the shared experience of choral music.

In Sonya Garfinkle's letter of 1960, she acknowledges that Singing City's $250 fee would be waived for their appearance at the convention but that help with transportation expenses would be greatly appreciated. A bus could be chartered from Philadelphia to Atlantic City for about $90. Singing City's performance strongly demonstrates ACDA's early and continuous conviction that quality choral music performance and practice transcends gender, racial, ethnic, and social boundaries.

SINGING CITY

Clubwomen's Center • Gimbels • Philadelphia 5, Pa. MArket 7-4455

Dr. Elaine Brown
Musical Director

Miss Sonya Garfinkle
Miss Janet Yamron
Assistants to the Director

Officers
Paul M. Chalfin
President
Matthew W. Bullock, Jr.
Vice President
W. Howard Green
Vice President
Bernard S. Weiss
Treasurer
Mrs. Estelle Colwin
Secretary

Board of Directors
Vivian Pennock Bailey, Jr.
Miss Bess Barg
Mrs. Robert H. Bonner
William Dobkin
Mrs. Phoebe Dorfman
Miss Elfriede Friese
William S. Gaitmor
Taylor Grant
James F. Griffith
Mrs. Ruth Weir Miller
Jerome J. Shestack
William R. Smith
Harry H. Soellenborg, Jr.
Raymond M. Steinberg
Mrs. Bernice Thompson
Dr. Fred D. Wentzel
Miss Katharine Wolff

February 11, 1960

Mr. Wayne Hugoboom, Program Chairman
American Choral Conductors Association
Manatee College
Brodenton, Florida

Dear Mr. Hugoboom:

I am writing in reference to the forthcoming performance of the Philadelphia Singing City Choir, conducted by Dr. Elaine Brown, at the convention of the American Choral Conductors Association Thursday evening, March 17, 1960, in Atlantic City.

As you may know, Singing City is a non-profit, service organization, completely dependent upon contributions it receives for programs for maintaining its annual budget. Normally, a minimum contribution of $250. plus transportation expenses is requested from all sponsoring organizations. In the particular situation of the American Choral Conductors Association, which we are pleased to service, we would not expect a contribution for Singing City, but would need to request a fee for transportation expenses. The cost of a chartered bus from Philadelphia to Atlantic City and return is $99.00. If there is any possibility that your organization could absorb these costs so that choir members would not have the expense of both their dinner and transportation, we would be most grateful to you.

Would you let me know in what hotel the meeting will be held on the evening of March 17, and at what time the Singing City Choir is expected to perform? Also, whom shall I contact regarding physical arrangements for the program, such as a rehearsal room where the choir can warm up and rehearse when they arrive, a set of four-leveled risers and a piano in good tune which they will need for the performance?

May I look forward to hearing from you at your earliest convenience?

Sincerely yours,

Sonya Garfinkle
Sonya Garfinkle
Assistant to the Director
Singing City

R. Wayne Hugoboom responded to Sonya Garfinkle's letter with a letter to Elaine Brown. He shares the financial situation of ACDA with her and offers information on what to expect at the convention. The format and situation were new, and no one knew what to expect. Hugoboom, as program chair, was there to guide them. He even invited them to arrive a little earlier than planned in order to take part in some of the interactive activities. Hugoboom requested a photograph of the choir for display at the convention.

February 6, 1960

Miss Elaine Brown
Singing City
Clubwomen's Center, Gimbels
Philadelphia, Pa

Dear Elaine Brown,

I have just written Miss Garfinkel today, but wanted to include you in my final letters to all directors and performing groups to be certain that everything was in readiness for the ACDA Conference and that all your needs are taken care of. I was sorry not to be more helpful in the matter of transportation, but I am sure you understand our position and precarious financial situation. Only hope that you may arrive at a satisfactory means of making the trip. You might check with some of the publishers in Philadelphia who will be exhibiting for ACDA and MENC and who might be willing to underwrite at least part of your expense.

The 22 Club in the Ambassador Hotel is at your disposal for rehearsal and changing robes for your appearance at 8:00 P. M. on Thursday, March 17th, for the final session of the ACDA Conference in the Renaissance Room. 80 chairs have been placed on the lower level of the Club; the piano is at the left of the steps on the Brighton Avenue side facing the conductor, who will stand on the steps. On the elevation at the right hand side of the club there will be several long racks and 2-5 covered tables for wraps and robes. A guide will call for you, lead you to the anteroom in readiness for your concert appearance. Risers and piano will be in readiness for you in the Renaissance Room and, I assure you, a large and enthusiastic audience. We shall also be anticipating your appearance on the panel immediately following the concert. We are deeply indebted to you for your fine cooperation and support in this venture and trust that we can arrive at several ways we can serve our members throughout the country aside from the conference, which many of the members cannot attend. If you have any suggestions be sure to pass them on. In the meantime, if there is any other information you need or any further equipment or arrangements, be sure to write me.

Harry Robert has asked me to invite you and your group to be present at the 4:00 Reading Session "Meet Your ACDA Composers" on Thursday afternoon, to be sure we had sufficient voices to hear the selections. From Miss Garfinkel's letter I have assumed that your arrival will be only in time for the concert, but if you can arrange to be there for the 4 o'clock session, we should be pleased but will understand if you cannot make it. With best personal wishes and in anticipation of hearing your group and renewing our passing acquaintance, I am

Cordially yours,

R. Wayne Hugoboom
Program Chairman, ACDA

IMPORTANT: Almost forgot!
Will you send me as soon as possible
a picture of the Singing City and
yourself. We want it for the Bulle-
tin Board during the Conference and it
will be returned to you, I swear!

AMERICAN CHORAL DIRECTORS ASSOCIATION

Statement of Receipts and Disbursements

March 8, 1960

Receipts:

194 Active Memberships $6		$ 1164.00
16 Class "A" Associate Memberships $25		400.00
2 Class "C" Associate Memberships $3		6.00
Total Receipts		$ 1570.00

Disbursements:

May 30, 1959	1st Stroudsburg, Pa. National Bank for checkbook	$	5.00
May 30, 1959	Albert J. Makovee of Port Richey, Fla. for Printing No. 1 Choral Journal, Letterheads, Envelopes & Membership Cards		205.90
August 10, 1959	Waring Enterprises, Inc. for Mimeographing Letter, Constitution and By-Laws and for Addressing Envelopes and for Postage		64.15
August 10, 1959	Albert J. Makovee for Printing membership cards and for postage		8.88
August 10, 1959	Oxford University Press for music used in Kansas City, Mo.		13.30
Dec. 3, 1959	Stroudsburg,(Pa.) Typewriter Co. for mimeographing letter and list		6.29
Dec. 3, 1959	R. Wayne Hugoboom for expenses incurred in arranging Atlantic City Program		22.70
Dec. 24, 1959	Earl Willhoite for Postage and other expenses		21.60
Dec. 24, 1959	Shawnee Press, Inc. for postage		10.40
Dec. 24, 1959	R. Wayne Hugoboom for expenses incurred in arranging Atlantic City Program		21.78
Feb. 18, 1960	D.L. & W. Railroad for freight for Choral Journal from Florida to East Stroudsburg,Pa.		54.24
Feb. 21, 1960	Albert J. Makovee for Printing No. 2 Choral Journal and membership cards		447.54
March 7, 1960	Stroudsburg Typewriter Co. for mimeographing letter sent to publishing firms		2.91
March 7, 1960	Shawnee Press for Postage, addressing and handling Choral Journal No. 2		383.52
March 8, 1960	Earl Willhoite for postage		10.09
Total Disbursements		$	1254.28

Total Receipts	$	1570.00
Less Total Expenditures		1254.28
Balance on Hand, March 8, 1960	$	315.72

A look at ACDA's balance sheet in March 1960 supports early members' assertions that there was no money in the bank to pay travel expenses. R. Wayne Hugoboom mentions ACDA's "precarious financial situation" in his letter to Elaine Brown, and a balance of $315.72 supports his claim.

The first ACDA convention featured five choirs: the Upper Darby High School Choir, the William Murrah Singers, the University of Delaware Concert Choir, the Choralettes of Scarsdale High School, and Elaine Brown's Singing City Choir. This program also demonstrates ACDA's early logo using the noted A, C, D, and A on a treble staff.

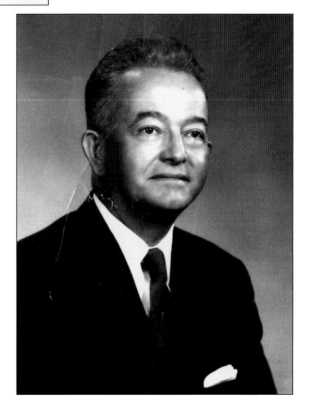

Clyde Dengler was conductor of the Upper Darby High School Choir, Upper Darby, Pennsylvania. His choir was one of the five choirs to perform at the 1960 national convention in Atlantic City, New Jersey.

American Choral Directors Association

General Session
Wednesday March 16, 1:30 P.M.

"STANDARDS OF CHORAL MUSIC"

MODERATOR: Elwood Keister

THE QUESTION: What is the status and trend of choral
performance and literature today in America?

Panelists

LLOYD SUNDERMAN: "The Singer": An overall picture of the choral singer
we work with---vocal requirements--his
background and ability--his taste in
literature. (Suggest late high school-
early college age level period), etc.

ROBERT BAYS: "The Teacher": A composite look at todays choral
director--quality of training--quality
of choral product--quality of musical
tools he is using (materials) trends, etc..

HARRY ROBERT WILSON: "The Composer": His problems--the need--the ivory
tower vs the compromise--the composer and
choral singer ability--Ford Foundation
Composer project--trends--etc.....

BENJAMIN GRASSO: "The Publisher: An overall look at the publisher and his
relationship and influence on choral
standards...factors involved in the deci-
sion to publish or not to publish---
business requirements--problems--trends--
etc.......

OLAF CHRISTIANSEN: "The Audience" An overall view------Their listening
ability and demands chorally--Their taste
in literature---an appraisel of listener
trends--enthusiasm--audience size--choral
maturity--etc....

The first annual convention featured a panel discussion between Lloyd Sunderman, Robert Bays, Harry Robert Wilson, Benjamin Grasso, and Olaf Christiansen on the question "What is the status and trend of choral performance and literature today in America?" This theme has been presented over and over in every ACDA conference throughout its history.

American Choral Directors Association

May 31, 1960

Mr. Maurice C. Whitney
Mr. Clifton A. Burmeister
Mr. David L. Wilmot
Mr. Frank D'Andrea
Mr. Robert E. Holmes
Mr. John T. Roberts

Copy

MENC Division Presidents

Gentlemen:

The American Choral Directors Association is working toward a divisional set-up similar to that of MENC. As a start in this direction, several of our members have suggested that we offer our personnel and facilities to each of the MENC divisions for the organization of a choral program. It just happens that we have a national officer or Board member in each of the divisional conferences.

I should be happy to have your reactions to the suggestions.

Cordially,

Archie N. Jones
President

ANJ:gh

At the first annual convention in 1960, a discussion took place related to membership recruitment that led to the idea of leaders being assigned to districts and states for the purpose of promoting the purposes of ACDA. No official action was taken at the time, but a few months later, a membership campaign was advised by Elwood Keister and the board of directors, resulting in the appointment of newly elected Curtis Hansen as membership chair. It was the suggestion of the board of directors that Hansen choose committee members from various areas of the country who would encourage ACDA membership in their own districts. From this action, two precedents were established: (1) that the vice president chair the membership committee; and (2) that ACDA be divided into geographic districts to insure better membership communication. As the divisions were based on MENC's existing structure, six divisions were created: Eastern, North Central, Northwestern, Southern, Southwestern, and Western. In 1979, the national board voted to split the North Central division into the North Central and Central divisions.

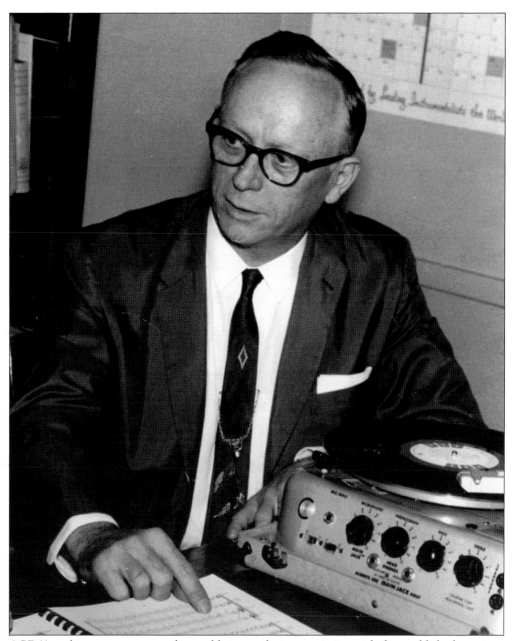

ACDA's early successes were made possible in part by its association with the established meetings of MENC. After a successful convention in 1960, ACDA asked MENC to be able to hold its 1961 national meeting in conjunction with MENC's North Central Division Conference in Columbus, Ohio. J. Clark Rhodes (pictured) was named program chair for the 1961 meeting. The convention featured a choreographed choir performance by Lima High School, presented with an accompanying interest session.

The Choral Journal

MAY 1960 *Official Publication of the American Choral Directors Association* NO. 3

ACDA Elects New Officers

Prior to the final business session of ACDA, President Archie Jones appointed Warner Imig, Carl Fehr, Don Malin and Don Foltz to act as a nominating committee to propose a slate of officers. Final voting resulted in the following list of ACDA officers for the 1960-61 year, culminating in the National Conference at MENC Divisional at Columbus, Ohio, April 6-10, 1961.

President, Archie N. Jones, U. of K. C., Kansas City, Missouri; Vice President, Curtis Hansen, Brainerd (High School), Minnesota; Secretary-Treasurer, Elwood Keister, U. of Fla., Gainesville, Florida.

Board members are Charles C. Hirt, U. of S. C., Los Angeles, California; R. Wayne Hugoboom, editor of Choral Journal, Manatee Junior College, Bradenton, Florida (1 year term served), new address as of Sept 1 will be University of South Florida, Tampa 4, Fla.; Warner Imig, U. of Colorado, Boulder, Colo. (3 year term; 1 served); Mary Ruth Palmer, Anderson (High School), Indiana; Harry R. Wilson, Columbia U., New York (2 year term; 1 served).

1961 Program Committee: Chairman, George F. Krueger, I. U., Bloomington, Ind.; Louis Diercks, O. S. U., Columbus, Ohio; Ferris Ohl, Heidelberg College, Tiffin, O.

1961 Tape Bank Committee: Chairman, Harold C Decker, U. of I., Urbana, Illinois; Walter S. Collins, U. of M., Minneapolis, Minn.; Walter Ehret, Scarsdale (High School), New York.

1961 Program Exchange Committee: Dr. Elwood Keister, Gainesville, Fla.

1961 Publicity: R. Wayne Hugoboom, chairman, Bradenton, Fla.; Kent A. Newbury, Harrison Tech High School, Chicago, Illinois.

1960 DUES NOTICES

Due to the normal delay in transfer of the books and records and reprinting cards, the new notices for this year's dues will be mailed to you in the near future. Since no fiscal dues were collected from former members at the National Conference, only from new members, it was decided at the Board meeting that all members who joined after July 1, 1959 will be billed for only $3.00 this year to balance their payments with length of membership. All members joining prior to that time will be billed the regular amount of $6.00, and following this year, dues will remain constant at $6.00 per annum regardless of time of acceptance. Anyone wishing to pay his dues now may do so at any time according to Dr. Elwood Keister, Sec'y-Treas. ACDA, Bldg. R, University of Florida, Gainesville, Florida.

Standards of Choral Music

(March 16, 10:00 a.m.)

Dr. Elwood Keister, Chairman

Speaking from a singer's viewpoint, Dr. Lloyd F. Sunderman of the University of Toledo, Ohio, deplored the negative effects of popular singing whereby a personality and an assumed "style" creates false impressions of singing and negates a solid vocal foundation and artistic expression. Since the inception of MENC in 1907 to provide the burden of inspiration and leadership for choral directors, there are gradual signs of improvement; the excellent choirs throughout the country whose travels and interchange of concerts provide new avenues of exchange, the great advance of the publishing industry in the past 15 years, the use of TV and radio for such performances as the Schola Cantorum's presentation of the Bach "Magnificat" last Christmas, the growth of District, State and National choral festivals and the use of Hi-Fi and TV in both home and school.

Despite some good vocal training and good choral conducting and singing, there still exists a great lack of basic knowledge of the voice and its treatment. The teacher shortage caused by the single salary schedule has brought in too many vocal "baby sitters", the overcrowded schools, the pressure for college preparation and overemphasis of other "solid" subjects, the problem of education minus musicianship, the false conception that music education and music are one and the same, all of these have conspired to bring about much mediocre and poor quality work.

On the brighter side, the growing building program which admits and in some cases insists on rooms for music, the development of the General Music program, the use of more appropriate choral arrangements or originals, and the

Continued on Page Three

use of professional directors for choral festivals is steadily growing. The need now is for more dynamic leadership from the choral directors. Both students and teachers need vocal training apart from choral activities; the colleges need more than a one-semester course in choral conducting and more careful selecting of those capable of studying and training seriously in the field of choral conducting to help supply the national needs.

Continuing from the teacher's viewpoint, Robert E. Baye of George Peabody College, Nashville, Tenn., remarked that most students who have gone into choral work have been trained in either piano or voice and have gradually evolved into good conductors. There is an urgent need for more direct training in choral conducting. It should become the center of emphasis in the training of the choral students whose study should not only include vocal and choral techniques but also a concentration on choral style and choral literature. Two dangerous trends are the present infatuation with "gimmicks" and stylization: something vastly different than a true style.

Having given the student the why and how to teach, we need still to give him the "what" so that graduates ready for teaching have a good basic knowledge of the voice, its training and handling, the various periods of choral composition and the correct style for each period and, finally, a working repertoire of good, basic choral literature. These are the working tools we need to give our young teachers to develop dynamic choral leaders in America.

Speaking on the composer's problems, Dr. Harry Robert Wilson of Columbia University, said, "Man cannot write what he is not." Good texts from the classics or from the Bible bring out the best in the composer and he is reflected in his

MEET OUR NEW VICE-PRESIDENT: Elected at the March ACDA National Conference, Curtis Hansen of Brainerd, Minn., is also President of the Minnesota Music Educators Association and a busy man as director of three choirs at Washington High School and a fourth at the Brainerd Junior College. His groups have sung for North-Central MENC at Milwaukee and at a breakfast concert at MENC National in St. Louis, as well as two appearances at Orchestra Hall in Chicago and many radio and TV concerts. A graduate of St. Olaf College, Mr. Hansen was a student of the late F. Melius Christiansen. He obtained his Master of Musical Education from Minneapolis College of Music and has since continued studies at Concordia College and Wake Forest. He has been at Brainerd since 1950. Aside from his work at school, he is also much in demand as a clinician and adjudicator throughout the Midwestern area and has just completed his 16th vocal clinic recently. We welcome Curt to the staff of ACDA.

Decker Appointed Chairman Tape Bank Committee

Harold C. Decker, Dean, School of Music, University of Illinois, has been appointed chairman of the tape bank project for the American Choral Directors Association. With him as committee members will be Walter Collins, choral director at the University of Minnesota, and Walter Ehret of Scarsdale High School, Scarsdale, New York.

The purpose of the tape bank is to provide a recording source for choral music in the standard repertoire which is not available at the present time on records. The committee will first compile a list of standard choral compositions in general use and then will seek to have recordings made of those compositions not already recorded.

NATIONAL, DIVISIONAL CONFERENCE DATES

To permit ACDA members to make definite plans for the coming year's meetings, our National Conference will be held at Columbus, Ohio, April 6-10, in cooperation with the North-Central Division of MENC. For the many members who will not be able to make the trip to Columbus, the Officers and Board Members of ACDA are now designating key people in each of the Divisions to work with MENC Planning Sessions, and plan to include one or more session, performance and luncheon meeting for each area, or to work with MENC in any way they wish to make our organization a contributing group to the Divisional conferences.

To assist you in arranging your time to attend either a Divisional and/or National meeting, here are the dates and place of each 1961 conference: Eastern, Washington, D.C., January 13-16; Southwestern, Albuquerque, N. Mex., January 27-30; Northwest, Spokane, Wash., March 15-18; Western, Santa Monica, Calif., March 26-29; North Central, Columbus, Ohio, April 6-10; and Southern, Asheville, N. C., April 20-23.

After receiving the approval of MENC officials, the following announcement appeared in the May 1960 *Choral Journal*: "For the many members who will not be able to make the trip to Columbus, the officers and Board Members of ACDA are now designating key people in each of the Divisions to work with MENC Planning Sessions, and plan to include one or more session, performance, and luncheon meeting for each area, or work with MENC in any way they wish to make our organization a contributing group to the Divisional conferences." The value of the regional meetings was indicated in a convention report by Warner Imig of the University of Colorado: "This type of contact at our divisional meetings of MENC are of first rank importance in our organization. This is the sort of grass-roots work that we need in order to service the choral conductors."

September 1961

THE
Choral Journal

VOLUME TWO
NUMBER ONE

Official
Publication
of the
AMERICAN
CHORAL
DIRECTORS
ASSOCIATION

A message from the President

On August 26 I met with the MENC Board of Directors in Washington, D. C. at which time we discussed the possibility of ACDA becoming an associated organization.

I am happy to report that by unanimous vote of the Board, ACDA is now officially an associated organization of the Music Educators National Conference.

In truth, our association with them has been going on from the very beginning, with their kindness and helpfulness apparent to all of us. This official confirmation of our ties will allow us to join hands with them in serving the high musical ideals and needs of both organizations.

Other associated organizations include the National Association of College Wind and Percussion Instructors, College Band Directors National Association, American String Teachers Association and the National High School Orchestra Association. Each of these organizations has been able to retain their individual identities while at the same time utilizing the tremendous resources and assistance of MENC.

I know it is your hope as well as mine that this association will prove to be a long and fruitful one.

On April 26, 1961, Elwood Keister attended the interim board of directors meeting of the MENC at the invitation of Vanett Lawler, MENC executive secretary. Written and verbal accounts of the event indicate that the MENC board members were interested in ACDA and most eager to assist the group. The board of directors of MENC voted unanimously that ACDA be admitted as an associated organization of MENC. This affiliation has prevailed since the 1961 vote. The acceptance of ACDA to associate membership in MENC was a noteworthy event in the history of the choral directors' organization. The size and strength of the older association helped to stabilize and direct the younger. From the first national convention in Atlantic City, through the 1964 meeting in Philadelphia, ACDA continued to grow at a steady pace. This growth was facilitated by added activity at the divisional and state level, and by ACDA's ongoing affiliation with MENC. ACDA continued to build and refine its organizational structure and committee definitions. Membership benefits such as conventions, networking, and publications were added.

Under Warner Imig's (pictured) 1962–1964 term of office, the association grew in size, and the importance of ACDA expanded. Additional achievements included the appointment of ACDA's first division chairs, an increase of ACDA activity in state chapters, and a major constitution revision.

REGIONAL CHAIRMEN

Bernard W. Regier

Dr. Lee Kjelson

Robert McCowen

Bernard W. Regier, ACDA Northwest Regional Chairman, is Director of Choral Activities at Western Washington State College at Bellingham, Wash. Well known, particularly on the West Coast where he has been actively engaged in choral activities, Bernard is also a fine baritone and appeared as soloist in the Brahms *German Requiem* with the College Chorus and College-Civic Orchestra under the direction of Frank D'Andrea.

We are particularly proud and happy to welcome Bernard as our Northwestern Chairman and predict that the coming years will bring a strong choral directors organization in that area. His fine musical accomplishments and pleasing personality make his choice an excellent one for ACDA.

REGIONAL AND STATE CHAIRMEN TO APPEAR IN SUCCEEDING ISSUES

Next issue we shall bring you pictures of the three other Regional Chairmen as well as start a series of thumbnail sketches and photos of our ACDA State Chairmen. The Choral Journal also welcomes pictures of groups, events, concerts, meetings, and outstanding personalities throughout the U. S.

We ask Regional and State Chairmen

Dr. Kjelson is the dynamic young director of Choral Organizations at Alameda State College, Hayward, California.

Dr. Kjelson's teaching positions have included public school positions in Nebraska and Iowa. Before going to Alameda in 1960, he served as Director of Choral Organizations at Western State College, Gunnison, Colorado.

One of Dr. Kjelson's most unusual characteristics is his versatility. He has taught, with outstanding success, on all levels of music education. His Doctoral Studies at the University of Iowa culminated in the production of two teaching films in which he demonstrated his belief in (and mastery of) the singing approach to Junior High General Music. His high school and college choirs and madrigal groups have been heard at state, division and national MENC conventions on many occasions, including the Chicago National in 1954 and the Southwest Division Conference in 1959.

At last count, Dr. Kjelson had twenty-three choral compositions in the catalogs of seven different publishers.

to send your Editor a clear photograph, small to medium size, accompanied with a brief sketch of background and present activities. Photos and sketches will be published as received rather than in alphabetical order.

Robert McCowen is associate professor of music at Iowa State University.

A native of Waterloo, Iowa, Professor McCowen received his bachelor of arts in voice in 1941 from the State College of Iowa and his master of music in 1951 from Northwestern University.

Professor McCowen directs the Iowa State Singers, the Iowa State Festival Chorus and the Iowa State Men's Glee Club and teaches voice and conducting. He has directed the all-state choruses in Iowa, Kansas, Missouri, Nebraska, North and South Dakota and Wyoming.

He has been choral director at summer music clinics for the University of Wisconsin, University of Kansas, Western Illinois University, Southwestern College, Utah State University, International Peace Gardens, and the Egyptian Music Camp.

He is director of music at Collegiate Presbyterian Church, Ames, and has been an oratorio and concert bass soloist on radio and television throughout the Midwest. Composer of "Alleluia" in 1959 and "Gloria in Excelsis Deo" in 1952, both sacred choral numbers, Professor McCowen is a member of the American Choral Directors Assn., the National Assn. of Teachers of Singing, Phi Mu Alpha, Pi Kappa Lambda, Music Educators National Conference, Iowa Music Teachers Assn. and the Ames Kiwanis Club.

Following the success of the 1961 division conventions, Archie Jones suggested that ACDA division chairs be appointed in each of the six established ACDA-MENC divisions. The responsibility of these chairs would be the organization of ACDA sessions at the odd-year conferences. ACDA president Warner Imig designated first vice president Elwood Keister to make the appointments and to serve as advisor for the newly established positions.

REGIONAL CHAIRMEN

Paul B. Fry

Stephen C. Hobson

Dr. Ivan Trusler

Introducing our Southern Regional Chairman, Paul B. Fry, choral director at Albemarle Senior and Junior High Schools and at the First Presbyterian Church, Albemarle, N. C. Graduating from Davidson College, N. C., and obtaining an M.A. in Music Education at Appalachian State Teachers College, Boone, N. C., Paul has continually augmented his educational background with summer work at the University of North Carolina at Chapel Hill, with the Westminster Choir School and the Fred Waring Summer workshops.

Aside from his regular duties, Paul's activities include Chairman of Curriculum Committee, Choral Section of NC-MEC; permanent registrar of their Summer Choral Workshop with Lara Hoggard as permanent director; chairman of the Albemarle District H. S. Choral contest, choral editor of the N. C. Music Education magazine, and a private vocal studio. A charter member of ACDA, his other memberships include MTNA, Pi Delta Theta, honorary education fraternity, NATS, National Secretary, Modern Music Masters Society, and State Advisory Council on Teacher Education for the State Department of Public Instruction. He is also ACDA State Chairman for North Carolina.

An able musician and worker, Paul is in charge of the Southern Conference ACDA program at Charleston, W. Va.

The Regional Chairman from the Southwest "territory" is Stephen G. Hobson, Professor of Vocal Music at Northeast Missouri State Teachers College in Kirksville, Missouri. This charter member of ACDA, who also serves as state chairman, has taught voice and directed choirs on the college scene for fourteen years. Believing strongly in a "grass roots" policy, Steve has initiated and directed fifteen voice clinics for high school students in his area, since 1958. He tries to lend first-hand assistance to high school teachers in creating a "voice consciousness" among young singers who attend.

Though devoting most of his energy to teaching Voice, Vocal Techniques, Choral Conducting, and Opera, Steve is a tenor soloist in his own right, and still finds time for voice and choral clinic work on the side.

His academic background includes a Bachelor of Arts in Public School Music from Iowa State Teachers College, a

on March 20, in conjunction with Southern MENC Regional Conference, March 20-23. Preliminary plans and projects, worked out at the Atlanta Conference Planning Session with J. Clark Rhodes, ACDA Secretary-Treasurer, and Harold Ewing, Charleston, W. Va., NATS representative for President Louis Nicholas, may be found elsewhere in this issue.

ACDA Eastern Regional Chairman, Dr. Ivan Trusler, is a native of Alabama and received his B.S. and M.S. degrees in music from Kansas State Teachers College at Emporia, and his doctorate from Columbia University. Prior to joining the University of Delaware faculty in 1955 as Director of Choral Organizations, Dr. Trusler was director of both vocal and instrumental music at Pretty Prairie, Kansas, Rural High School, and later director of choral music at Emporia, Kansas, Senior High School. During his tenure in Kansas, he was choir master of the First Baptist Church of Hutchinson and the First Presbyterian Church of Emporia. While in New York City, he organized and was the first conductor of the Y.W.C.A. Chorus of New York.

Dr. Trusler is responsible for the training and direction of all three of the University's choral organizations — the Varsity Chorale, the Concert Choir, and the Women's Chorus — in addition to heading the voice department. His engagements as guest conductor of Choral festivals and clinician have taken him throughout the U. S. He is Director of Music at Grace Methodist Church of

—Continued on Page 22

Master of Music from Northwestern University, and a Doctor of Philosophy in Music Literature and Performance from the State University of Iowa.

The newly appointed chairs were introduced to ACDA membership through *Choral Journal* in the September and November 1962 issues. These chairs were Ivan Trusler, University of Delaware (Eastern Division); Paul B. Fry, Albemarle, North Carolina, public schools (Southern Division); Robert McCowen, Iowa State University (North Central Division); Stephen G. Hobson, Northeast Missouri State Teachers College (Southwestern Division); Bernard W. Regier, Western Washington State College (Northwestern Division); and Lee Kjelson, Alameda State College (Western Division).

The 1962 convention concluded with the combined choirs of the University of Colorado and the University of Illinois, under guest conductor Roger Wagner. The session concluded with Carl Orff's *Catulli Carmina*. The excellence of convention performance standards was indicated in the results of national convention evaluations resulting from the Columbus and Chicago conventions. The events evaluated included clinics, demonstrations, and open rehearsals, with the open rehearsals of the Colorado and Illinois choirs directed by Roger Wagner being the most popular. The choral performance events were rated as the second most popular. The photograph above of Roger Wagner was taken in 1978.

ACDA
Awards Announcement

♉

THE AMERICAN CHORAL DIRECTORS ASSOCIATION

announces the

Schmitt Foundation Award
($500.00)

and the

J. W. Pepper Award
($500.00)

For the Best Compositions
of Choral Music

During Elwood Keister's one-year administration as ACDA president, the association continued membership growth and sponsored its first award at the 1962 convention in Chicago. Two awards of $500 were given to two separate composers, one for a sacred work and one for a secular work. Richard Toensing won the sacred award for his composition "Gloria Domine," and Walter Wade won in the secular category for "Arise My Love." These awards were sponsored by the Schmitt Foundation and the J. W. Pepper sheet music company.

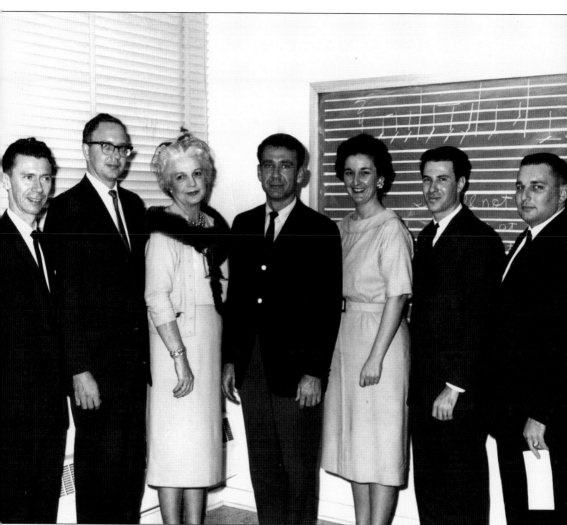

Illinois was the first state chapter to officially organize in the summer of 1963. Before this time, state groups did meet, but they were not state chapters. In this photograph, Alabama ACDA met at Troy State College in Troy, Alabama, on January 16, 1963. The group discussed strategies for creating more interest in choral music and attended a concert by the Vienna Boys' Choir. Pictured are, from left to right, Charles V. Farmer, Thomas Warren, Mrs. Merle McCorkle, Herff Applewhite, Ellen Dudley, Lawrence Rosenbaum, and Roy Watford.

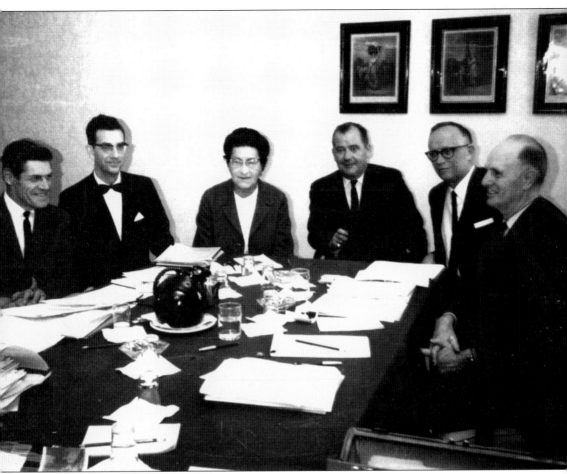

Under the leadership of division chairs, the 1963 ACDA divisional conventions developed. In four of the six divisions, ACDA gatherings were concentrated into one full day held prior to the MENC events. The Western and Northwestern Divisions arranged sessions within the framework of the MENC convention. Symposia, demonstrations, reading sessions, panel discussions, lectures, and performances were featured in the various program formats and were open to all ACDA and MENC members. Most divisions also included a breakfast, luncheon, or dinner meeting for ACDA members. Several MENC-ACDA cosponsored events were included in the MENC programs. The group above met to plan the future of ACDA at the Eastern Division Convention in Atlantic City, New Jersey. Pictured are, from left to right, R. Wayne Hugoboom, editor, *Choral Journal*; Elwood Keister, first vice president; Helen Hosmer, second vice president; Warner Imig, president; J. Clark Rhodes, secretary-treasurer; and Earl Willhoite, advisory board member.

During the summer of 1963, a project sponsored by the choral section of the North Carolina Music Educators Conference (NCMEC) took place. Lara Hoggard was guest director at the workshop, attended by 350 students and directors. The workshop enjoyed such immense popularity that subsequent workshops were unable to accept out-of-state applicants. In this photograph, those responsible for the workshop are pictured including, from left to right, Paul B. Fry, NCMEC registrar and ACDA Southern Division chairman; Mrs. J. R. Blackwell, president of NCMEC and ACDA member; Robert H. Ellis, chairman of the NCMEC choral section and ACDA member; Lara Hoggard, permanent director of the NCMEC workshop and director of the Midland-Odessa Symphony Orchestra and Chorale; and Joel Carter, music department at the University of North Carolina at Chapel Hill and coordinator of the NCMEC workshop.

Vice President Hosmer
LISTS
ACDA Activity Areas

HELEN M. HOSMER

The following material submitted to the National Officers by Second Vice President Helen M. Hosmer is a compilation of suggestions received by her from various State Chairman in response to her request for suggestions. A further letter from President Warner Imig was forwarded to all State and Regional Chairmen summarizing this material to keep them informed and alive to the vast possibilities of our organization.

Since we are a dynamically moving and growing organization, it should not be left up to the State Chairmen alone to bear the responsibility for activities in their own realm, but should be the individual responsibility of each of us to act in any way we can to further ACDA in our own area. The materials, suggestions, and ideas listed below give each of us a job: it may be one of working alone in our community to attract other capable directors to our group, it may mean the concerted efforts of Directors within a county or in a district of the state under supervision of your chairman, or it may mean a call to full and close cooperation with your State Chairman in setting up an ACDA meeting. The fact is, the implication is inherent in every remark: ACDA is as strong as its individual members, and in our unity of purpose and continued activity lies our great national strength.

While we don't advocate each of you to take over the duties of the Chairman, we invite you to read this memorandum, keeping in mind that you are responsible for the growth and development of ACDA in your state. There are many other good ideas which may not have been mentioned. We are certain that both your State Chairmen and Miss Hosmer will be happy and appreciative of your thought and effort if you will contact them. In this spirit of provoking thought and action, we publish this Memorandum. *Editor.*

General Suggestions

Become familiar with the *ACDA Bulletin of Information* and the *Constitution* and with its revision to be reprinted in the near future. In these two publications you will find many worthy ideas. Our aims and purposes are most commendable, and in national unity there is strength.

In the last analysis we hope that ACDA will upgrade every facet of choral music in the United States. This can be done in so many ways that you are virtually obligated to thoroughly study the aims in order to see what may be applied in your particular area and situation.

Membership

Distribute Bulletins and past issues of The Choral Journal as generously as possible to all prospective members.

Ask key people to recommend outstanding choral directors to the state chairman. The most successful approach has been to forward a personal letter of invitation to join, accompanied by a brochure and an issue of The Journal.

Stress the calibre of our membership. On alternate months there is a list of new members and the total membership contains the names of many nationally known choral conductors. Re-read your Journal lists.

State Activities

As far as possible, accent your procedure at the *State level.* It is often wise to set up a state steering committee. Try to form state chapters in connection with state professional meetings. See the article in this issue on the Illinois Chapter.

In planning meetings, it has proven helpful to keep the following in mind:

Enlist the help of as many people as possible, since there is added impetus in successful group and/or joint efforts.

Enlist the help of dealers and publishers.

Vary the type of meeting: consider informal breakfasts, luncheons, teas, coffee hours and dinners.

Encourage as many smaller informal district meetings as possible for the exchange and discussion of professional ideas.

Make ACDA felt at different types of professional meetings.

Hold ACDA meetings in conjunction with any already established choral clinics or festivals.

Be willing to help select offerings for state meetings.

Where possible, try to have special sessions or even a day set aside for ACDA activities.

Publications

Make wise use of publications regularly and often.

Send material regularly to the Editor of The Choral Journal.

Contribute to your state bulletin and to M E N C publications concerning ACDA organization, aims, principles, and objectives.

Announce all meetings, regional, state, and local in your magazine.

Send publicity to music schools and to summer music camps: a successful venture in several states.

Dispense an abundance of publicity material at all types of meetings.

Additional Types of Activities

PANEL DISCUSSIONS are valuable and have been very successful in certain states, especially if carefully charted in advance. One program presented an integrated and broad approach by having panel members who were rep-

As the association considered various activities and benefits for membership to ACDA, second vice president Helen Hosmer developed a list of helpful and constructive ideas and activities, resulting in an article written and distributed to all state chairs. As a result, the following ideas were generated: (1) that at least one organizational meeting be planned for the year; (2) that church musicians and young choral directors be involved in the meetings; (3) that new memberships be secured; and (4) that the upcoming 1964 national convention be publicized throughout each state.

Warner Imig initiated the affiliation proposal between ACDA and the Texas Choral Directors Association (TCDA) in February 1964. TCDA preceded ACDA by four years, and with its large and active choral director base, it was a natural fit for affiliate status with ACDA. Discussion continued throughout spring and summer 1964 and culminated with the Texas Choral Directors Association convention in August 1964.

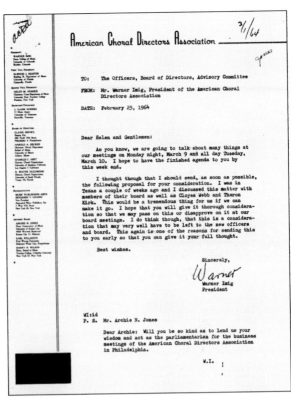

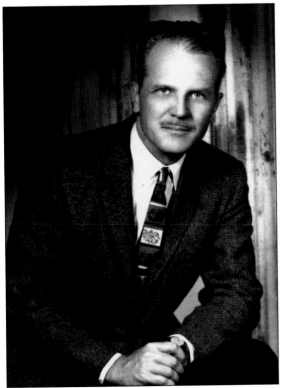

Theron Kirk, national ACDA president (1968–1970) lobbied hard for this ACDA-TCDA affiliation. Cloys Webb was president of TCDA at the time of the affiliation and on February 17, 1964, Webb made the "official overture to A.C.D.A. for the establishment of an affiliation between the two associations." With this, Texas became the first state to affiliate with ACDA.

49

Following the 1962 national convention in Chicago, ACDA began operating on a biennial system with the even years reserved for national conventions and the odd years used for division conventions. Choral performances were always considered to be the most important feature of a convention. In this photograph, members gather for a reading session with Lee Kjelson, who presided over the event, and Richard Ringenwald, accompanist. The photograph was taken on March 12, 1964, at the national convention in Philadelphia.

ACDA conventions have always been a time to network with friends and colleagues. Many times, this desire for a time of scheduled socializing appears on convention evaluations. A kaffeeklatsch, hosted by the Philadelphia chapter of the American Guild of Organists, was attended by ACDA members at the 1964 national convention in Philadelphia. It provided convention attendees the chance to enjoy this routine convention feature.

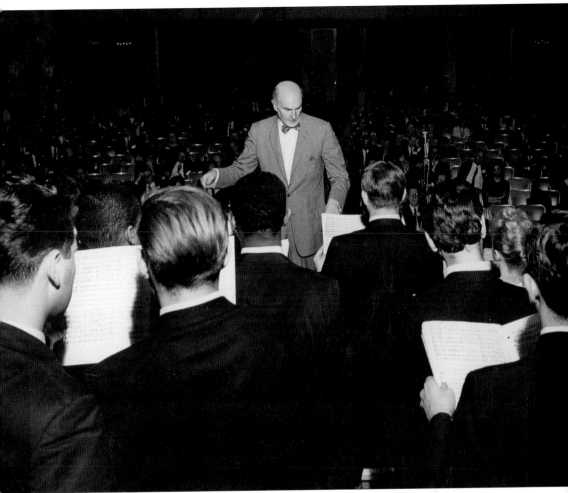

Life memberships were a new feature to ACDA in 1964. The 1964 Philadelphia convention honored two individuals by awarding them honorary lifetime memberships. In this photograph, Hugh Ross, recipient of one of the first honorary ACDA life memberships at the 1964 convention Philadelphia, conducts the Manhattan Choir at the convention.

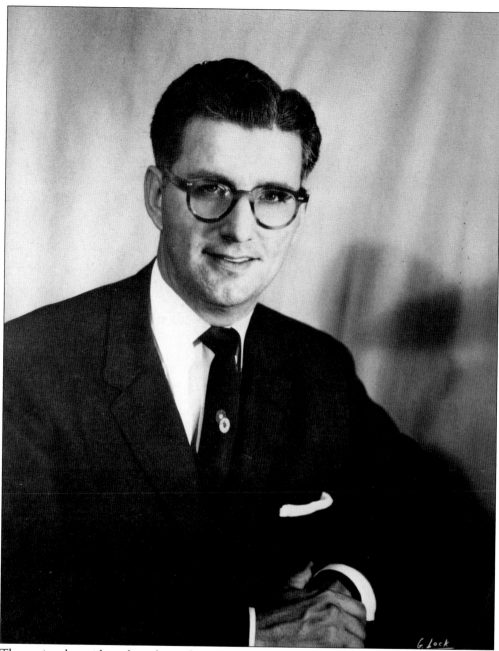

The national president-elect chairs the year's convention (exceptions to this practice occurred in 1960, 1964, and 1977). Charter member Don Razey has the distinction of being one of the few nonpresidents to have chaired a convention. Razey chaired the 1964 Philadelphia convention.

State activities continued to expand in 1964. In this photograph, Robert Larsen analyzes a score before his lecture at the Northwest Iowa Madrigal Festival. The festival was the first activity to be held by an ACDA district in Iowa.

Eugene Pence is listed as a "new member" in the February-March 1964 issue of *Choral Journal*. Pence became the first life member just a few months later in May 1964. A life membership in 1964 cost $100 and was payable in five installments of $20.

May 25, 1964

Mr. Eugene E. Pence
541 East 112th Street
Chicago 28, Illinois

Dear Mr. Pence:

Congratulations! You are the first ACDA member to take advantage of the new life membership plan. I sincerely believe that this will be a worthwhile investment for you as a member and I am sure that ACDA will gain, not only financially, but in strength of membership through this program.

Will you kindly send a photograph of yourself and a brief biographical sketch to Mr. R. Wayne Hugoboom, Editor of the *Choral Journal*, P. O. Box 17736, Tampa, Florida, 33612. There is a possibility that he might be able to run a little item in the next issue of the *Journal* in connection with this membership.

It is our plan to give a "Life Membership Card" and a "Life Membership Certificate" to life members. These have not been developed at this time, but we plan to have them ready to mail by September.

Cordially yours,

J. Clark Rhodes
Secretary-Treasurer
(President-elect)

JCR:rm

CC: Board of Directors

Pence was asked to provide a photograph and a biography of himself for publication in *Choral Journal*. The announcement was included in the October/November 1964 issue.

American Choral Directors Association

This is to certify that

LIFE

is a fully paid Life Member of this Association

NO.

EXECUTIVE SECRETARY

SECRETARY-TREASURER

This is an example of an original ACDA life membership card. The letter to Eugene Pence stated that ACDA had not yet designed the cards when he became the first life member, but the association hoped to have them in place by September 1964. Life members pay a predetermined amount in installments. Once they reach that amount, they receive a certificate and the benefits of ACDA for life.

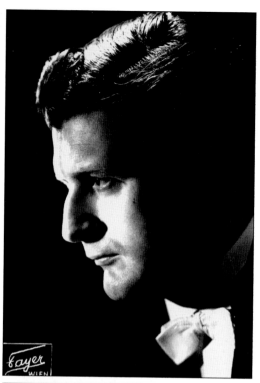

In 1964, Gerhard Track, music director of St. John's University Men's Chorus, had previously been the conductor of the Vienna Boys' Choir. He achieved this accomplishment at the impressive young age of 28.

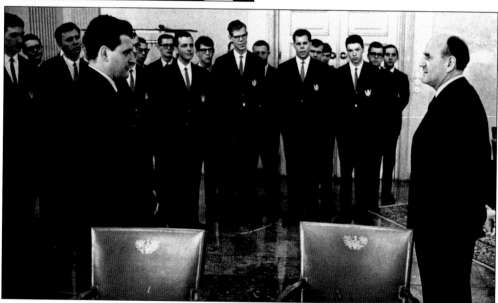

Gerhard Track took the St. John's University Men's Chorus on European tours multiple times. The chorus first toured in 1960, singing 30 concerts in Germany, Austria, and Switzerland. It returned in 1962, when a full house in the Vienna Brahms Hall requested seven encores. The choir also competed in choral competitions in Wales where it took home prizes. St. John's chorus was to return for another 30-concert tour of Sweden, Germany, Austria, and England in 1965. Above, Austrian prime minister Josef Klaus welcomes the St. John's University Men's Chorus in his office in Vienna.

TCDA officially affiliated with ACDA at its state meeting from July 30 to August 1, 1964.
Pictured above is Cloys Webb, TCDA president (1963–1965).

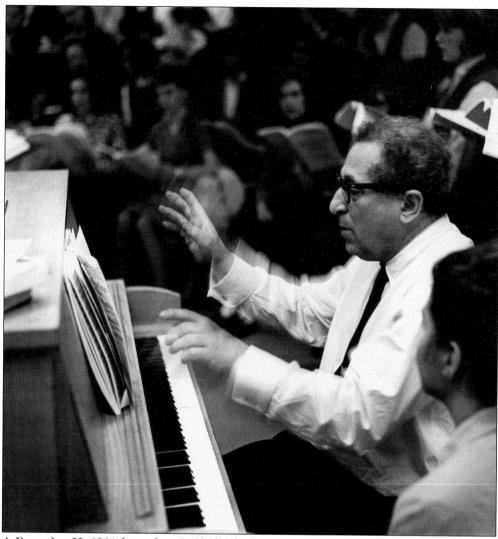

A December 22, 1964, letter from J. Clark Rhodes to Harold Decker illustrates Julius Herford's enthusiasm for ACDA and his desire to steer *Choral Journal* in a more academic direction. Herford, according to the letter, was an enthusiastic supporter of ACDA but felt that the organization was in danger of losing some of its more distinguished members if it did not include more articles "based on sound musicology and practice." Pictured above, Herford works with the Scottish Rite Choir at the University of Tennessee on November 11, 1960.

State conventions and workshops were often chronicled in early issues of *Choral Journal*. In this picture, Morris Beachy conducts a reading session at the Southwestern Division convention on February 26, 1965. Choral reading sessions have always been an important feature of ACDA conferences.

This animated photograph captures
ACDA member Jester Hairston
conducting folksong arrangements
to an enthusiastic Roseburg High
School A Cappella Choir at the
Northwest Division convention
on March 31, 1965. Hairston was a
noted arranger of African American
spirituals and a Hollywood celebrity.
He is well known as the composer
of the theme song for the television
show *Amen*, and is one of the three
participants in the ACDA *On
Location* video series.

The a cappella choir at Pampa High School performed at the 1966 ACDA National Convention in Kansas City, Missouri, under the direction of future ACDA national president Hugh Sanders (1985–1987). The choir was a highly honored choir receiving Division I ratings in sight-reading and concert performance in the Texas University Interscholastic League Competition. Sanders himself was highly regarded by his peers long before his election as ACDA national president. By 1966, he had been elected as vice president of vocal chairman for the Texas Music Educators Association and in 1964 was named Outstanding Young Man of the Year by the junior chamber of commerce.

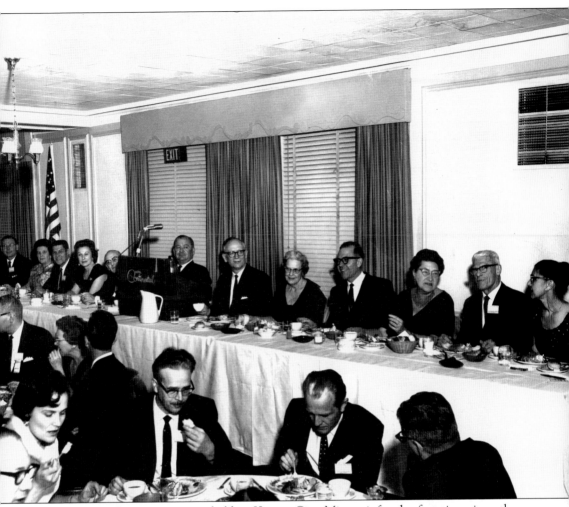

The 1966 national convention was held in Kansas City, Missouri, for the first time since the 1959 organizational meeting. The first ACDA banquet honoring its seventh year was held on Thursday, March 17, 1966. Warner Imig, first vice president, acted as master of ceremonies. Charter and life membership certificates were presented by ACDA president J. Clark Rhodes. Seated at the head table are, from left to right, Harvey E. Maier, Mrs. Olaf Christiansen, R. Wayne Hugoboom, Mrs. Harold A. Decker, Archie N. Jones, Warner Imig, J. Clark Rhodes, Mrs. Archie Jones, Harold A. Decker, Helen Hosmer, Olaf Christiansen, and Mrs. J. Clark Rhodes. Those seated in front of the table, from left to right, are Walter Rodby, Helen Louise Graves, Elwood Keister, Mr. and Mrs. Herbert Pankratz, Theron Kirk, and Don Razey.

Pictured are, from left to right, the recipients of the 1966 Honorary Life Membership Award: Archie Jones, ACDA's first president (1959–1961) and Olaf Christiansen, chairman of the music department at St. Olaf College, Northfield, Minnesota.

On January 27–28, 1967, Iowa ACDA held a well-attended convention in conjunction with the Iowa Music Educators Convention. The first Robert McCowen Award was given to Jane Ruby of Fairfield, Iowa. Pictured are, from left to right, Gordon Lamb, Jean Berger (registering), Joe McCoy, and Jane Ruby, secretary.

The state ACDA chapters were busy in the 1960s, and Ohio was no different. Maurice Casey (left), clinic chairman and future ACDA national president (1983–1985), and Ernest Hisey, ACDA Ohio chairman, check the conference schedule for the Ohio ACDA clinic on July 9–12, 1967. Over 80 choir directors attended this event.

ACDA established a national headquarters in Tampa, Florida, in August 1967 with the purchase of a small two-bedroom house. In the living room, a crack in the foundation gave way to grass that grew inside the building. R. Wayne Hugoboom worked out of his own home before this purchase, but soon, with a staff that included Phyllis Newberger, R. Wayne Hugoboom, and Hugoboom's sister, brother-in-law, and nephew who helped publish *Choral Journal* and track the growing membership, they outgrew the Hugoboom home and kitchen table. Hugoboom stated, "When the equipment and two secretaries who worked daily in our home became too burdensome, the Tampa office was purchased and we regained part of our house, but my office and the kitchen table are reserved for ACDA." Hugoboom became full-time executive secretary in 1968, continuing to work primarily out of his home. He also spent some time at the humble new headquarters, which came Florida-complete with a resident alligator in the adjoining swamp.

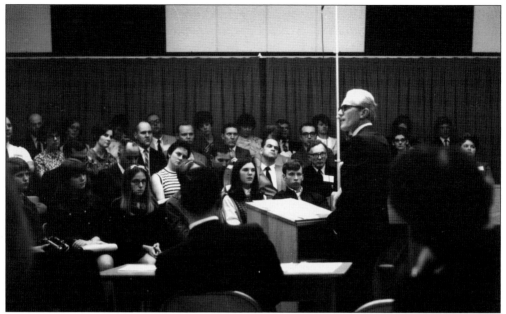

Division conventions continued in their popularity throughout the 1960s under the auspices of MENC and it would still be another year before ACDA began to hold independent division and national conventions. In this image, national president Theron Kirk addresses the ACDA special session at the Northwest Division convention in Eugene, Oregon, on March 20, 1969. Only a portion of the large crowd attending the session is pictured.

The Ponca City (Oklahoma) High School Chorale, directed by Robert E. Moore, performed at the Southwestern ACDA convention in St. Louis on March 5, 1969.

Choir directors from five states attended the choral workshop cosponsored by the music department of Montana State University and ACDA. The event was held on June 15–20, 1969. According to Harold Decker, Montana was "setting high standards in choral music, if the general interest and ability of directors and students in the workshop are any indication." Pictured in the first row are, from left to right, two unidentified, Dan Nelson (cochairman), Jean Berger (clinician), Harold Decker (clinician), Bruce Browne (cochairman), and unidentified.

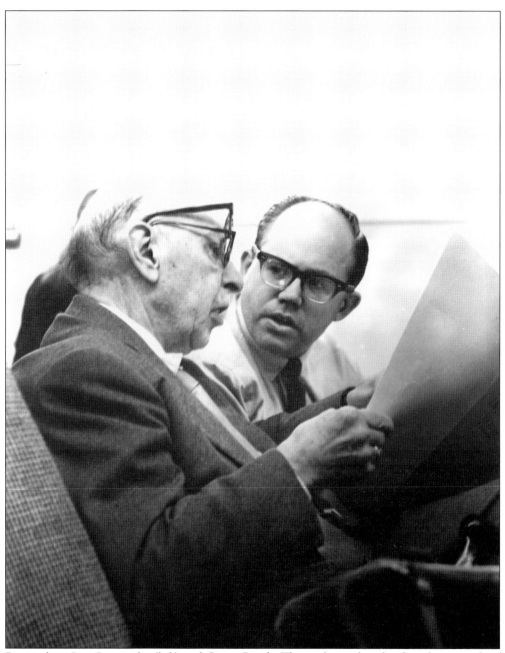

Pictured are Igor Stravinsky (left) and Gregg Smith. Their relationship developed as a result of the popularity and success of the Gregg Smith Singers. The two worked together from 1959 until Stravinsky's death in 1971. Smith formed his ensemble in West Los Angeles in 1955 and moved it to New York in 1970.

Three

THE SECOND GENERATION

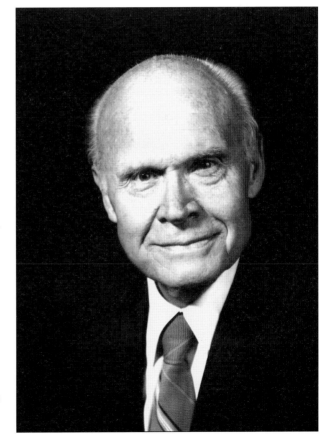

Howard Swan served as Western Division president of ACDA from 1964 to 1967. He never served as an ACDA national president, but was just as influential as any of them. He was on the faculty of Occidental College in Los Angeles and conducted the Occidental Glee Club from 1934 to 1971. He lost his ability to sing early in life, but that loss did not deter him from being one of the finest and most respected choral directors of his generation. Swan's *On Location* interview is the second in the series.

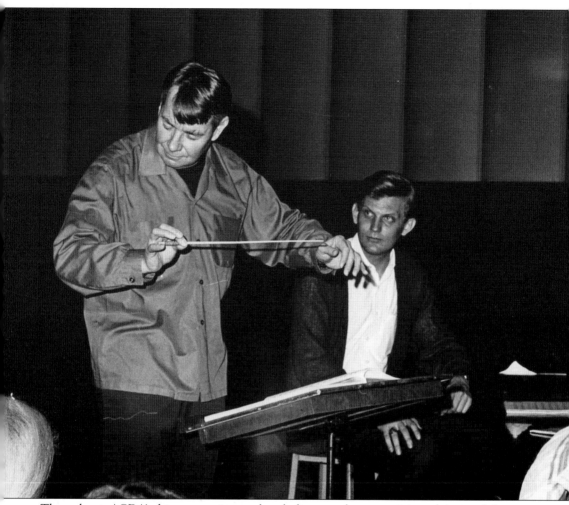

Throughout ACDA's history, eminent choral directors have participated in workshops at American colleges and universities. In this photograph, Robert Shaw (conducting) is pictured with Joseph Flummerfelt in rehearsal with the University Singers and Chamber Choir at the Florida State University School of Music in 1970. Shaw was mentor to a number of younger conductors throughout his life, including Ken Clinton, Donald Neuen, and Ann Howard Jones. He inspired thousands of singers throughout the world, and his many recordings are benchmarks for choral singing.

From 1969 to 1973, symposia were held in Vienna, Austria, with the goal of investigating the convergence of music, history, art, and architecture, while studying the musical style and performance practices of a particular period in light of historical and intellectual development. Each year a slightly different focus emerged from the symposia, but the overall theme remained consistent. The symposia were the result of the work of ACDA national president Harold Decker (1966–1968), and over 200 American choral directors from high schools, colleges and universities, and churches attended this annual event. Executive director Gene Brooks, who at the time was a professor at Midwestern University in Wichita Falls, Texas, took his choir to participate in the 1971 symposium. In the photograph above, Russell Mathis (fourth from left) poses with other 1970 participants. In the photograph at right, an animated Harold Decker is hard at work conducting.

ACDA
National Convention

MARCH 4-6, 1971
Kansas City, Missouri

ACDA's first independent national convention took place in Kansas City in 1971. Since 1971, national conventions have been held every two years, with the seven division conventions taking place during alternate years. Conventions are planned and executed through the work of a convention steering committee and the convention committee, both working in close relationship with the executive director and the staff of the national headquarters.

74

In this photograph, director James McRaney and the Honor Chorale from Cross Keys High School in Atlanta, Georgia, present actor Danny Thomas with a check for $250 for St. Jude's Research Hospital, a hospital founded by Thomas.

Jane Skinner Hardester had a long, distinguished career in ACDA's Western Division. She was president from 1971 to 1975. In a 1996 tribute to Skinner, Marlene Miller wrote, "She so touched and inspired me, that she remains the single most important figure of my youth. *Mr. Holland's Opus*? Don't make me laugh. That movie's hero was a real lightweight compared to the impact of Jane Skinner. . . . She'll always be Miss Skinner to me." Skinner served on the faculty of El Camino College in Torrance, California. She has been described as a "conduit for the choral art, transmitting her artistic vision to her choristers and to her audiences." The Western Division of ACDA has named the Jane Skinner Hardester Memorial Award in her honor to help aspiring composers attend workshops and conventions.

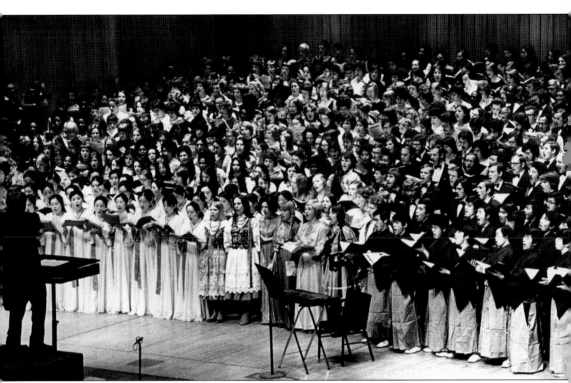

In another example of ACDA's involvement in worldwide choral music initiatives, ACDA members participated in the final April 30, 1972, concert of the third Lincoln Center International Choral Festival in Lincoln Center's Philharmonic Hall. Pictured above is Robert Shaw leading hundreds of young singers in this final concert.

GUIDE FOR THE BEGINNING CHORAL DIRECTOR

AMERICAN CHORAL DIRECTORS ASSOCIATION

ACDA has published 13 monographs (scholarly books) that are available to the public as a fulfillment of its original research purpose statement. They range in topic from a beginner's guide to choral conducting, to a compilation of all music performed at ACDA conventions between 1960 and 2000, to a book on Hungarian choral music. The first of ACDA's monographs, *Guide for the Beginning Choral Director*, was published in 1972 and was authored by the consortium National Committee on High School Choral Music.

NOMINEES FOR NATIONAL OFFICES

FOR PRESIDENT ELECT

FOR SECRETARY-TREASURER

WALTER S. COLLINS **COLLEEN J. KIRK** **GENE BROOKS** **J. EUGENE McKINLEY**

Walter S. Collins is associate dean and professor of music at the University of Colorado College of Music at Boulder in the Division of Choral Music and Musicology. Following his ten years at Oakland University, Rochester, Michigan where he was founding chairman of the music department and originator of the Meadow Brook Music Festival. From 1965 through 1969 he served as dean of the Meadow Brook School of Music, which operated as an academic adjunct to the summer festival.

Collins received his BA and BM degrees from Yale University, 1948-1951, MA and PhD degrees from the University of Michigan in 1953 and 1960. At Yale he served as president and assistant director of the Yale Glee Club and director of the famed Whiffenpoofs. He was also director of the University of Michigan Men's Glee Club 1955-56. A recipient of the DeForest Scholarship at Yale and a Fulbright Scholar at Oxford University in England in 1957-58, Collins was director of choral music at the University of Minnesota, 1958-60 and instructor and director of choral music at Auburn University from 1951-55.

He is a frequent adjudicator and clinician at choral festivals and author of a recently published book titled "Choral Conducting — A Symposium." He has edited many early choral music publications and has prepared choruses for the Minneapolis, Cincinnati, and Detroit Symphony Orchestras.

A frequent contributor to the **Choral Journal**, Collins has served as editor of the "Da Capo" column since 1971. He has held offices in ACDA as Michigan state chairman 1961-65, National Program committee member 1962, Regional program committee 1967, nominee for national President 1966, Editorial Board, 1964-66, 1969 to present, and since 1966 has served as chairman of the Choral Editing Standards committee. He is presently serving a second term as national president of the College Music Society, an association of 2,000 teachers of college and conservatory music teachers, and a member of MENC, the American Musicological Society, Phi Mu Alpha Sinfonia and Pi Kappa Lambda.

《《》》

Colleen J. Kirk serves as Professor of Music at the Florida State University. She holds B.S. and M.S. degrees in Music Education from the University of Illinois and the Ed.D. degree from Teachers College, Columbia University.

Prior to assuming her present position, Miss Kirk taught in public schools and on the faculty of the University of Illinois, where she also served as Chairman of the Music Education Division.

Miss Kirk has had extensive experience as a choral conductor and she is respected for developing innovative programs of choral music education. She has served frequently as conductor of festival choruses, as workshop clinician in vocal, choral and general music, as adjudicator for choral festivals and competitions, and as speaker and panel member at professional meetings. She teaches choral literature and conducting, choral techniques and graduate courses in music education; and advises graduate students. She has served as Director of Music at Wesley Church and Student Foundation on the campus of the University of Illinois and as Director of Junior and Senior High School Choruses for Illinois Summer Youth Music and for the Florida State University Summer Music Camp.

Professional affiliations include membership in ACDA, the MENC, the Florida MEA, Florida Vocal Association, the Florida College Music Educators Association and AAUP. She is a member of Pi Kappa Lambda, Sigma Alpha Iota and Kappa Delta Pi. She has served Sigma Alpha Iota as National Chairman of its International Music Fund.

Miss Kirk is currently serving as President of the Southern Division of ACDA. Her biography appears in **Outstanding Educators of America for 1972.**

《《》》

Gene Brooks is Chairman of the Department of Music and Choral Director at Midwestern University, Wichita Falls, Texas. He received his undergraduate training at Oklahoma Baptist University, his master's and doctor's degrees from the University of Oklahoma. He has completed additional graduate studies at the University of Colorado. His choir from Midwestern University participated in the 1971 ACDA Choral Symposium in Vienna, Austria. They have also been invited to

perform at the 1974 MENC national convention, Anaheim, California. He has been at Midwestern University for five years; prior to his teaching at Midwestern University, he was Chairman and Choral Director at Cameron State College, Lawton, Oklahoma, for seven years. His choirs at Cameron State College performed at the 1969 national convention of Music Teachers National Association, Cincinnati, Ohio. They also appeared at the 1969 state convention of the Oklahoma State Music Educators Association at Oklahoma City.

From 1970 to 1973, he served as National Choral Chairman for the Music Teachers National Association. He is now serving as Chairman of Music in Higher Education for MTNA.

He is a life member of ACDA and he served as National Convention Program Chairman for the 1973 national convention in Kansas City. He is also serving as Southwestern Division Convention Program Chairman, March 8 and 9, 1974, in Dallas, Texas.

In addition to being a life member of ACDA, he is also a life member of MENC and is a member of MTNA, TMEA, TCDA, TMTA, and Phi Mu Alpha Sinfonia.

《《》》

J. Eugene McKinley is chairman of the Music Department and director of choral activities at the Iowa Central Community College at Fort Dodge. He holds a B.A. degree in music education with voice emphasis from St. Ambrose College, and an M.A. from the University of Northern Iowa with post graduate work including workshops with Robert Shaw, Douglas McEwen, Gregg Smith, Paul Salamunovich, Robert Fountain, and others.

He was vocal music director at West Branch Community Schools 1959-61; at the Independence Community schools 1961-67 where he was founder and director of the St. John's Men's Choir and the Concert Chorale. Since 1967 he has been at Iowa Central and is past president of the Fort Dodge Area Fine Arts Council and conductor of the Fort Dodge Choral Society.

McKinley has served as guest conductor, adjudicator and clinician throughout the midwest, has performed with his ensembles at many business and profes-

—Continued on next page

In the summer of 1973, ACDA president Morris Hayes nominated Gene Brooks for the position of secretary-treasurer, and Brooks accepted the nomination. Brooks won the election that followed and served as secretary-treasurer from July 1974 to April 1977. In 1975, the executive committee decided to drop the word *secretary*, and the title became *treasurer*. The photograph above was used in the October 1973 *Choral Journal* for Gene Brooks's candidacy.

In 1974, 36 ACDA members and their spouses took part in U.S. president Dwight Eisenhower's People to People International program. The program was started in 1956 on the belief that if regular citizens got to know their counterparts in other countries, they might be able to do more for peace and humanity than could any governmental agency. In this photograph are, from left to right, Lynn Whitten, Harriet Simons, Ursula Vaughan Williams, and English choral conductor John Alldis.

On the same trip, ACDA members visited Poland, a first for most of them. ACDA guests listened to the Harfa Society conducted by Jerzy Kolaczkowski at a concert specially arranged for the occasion.

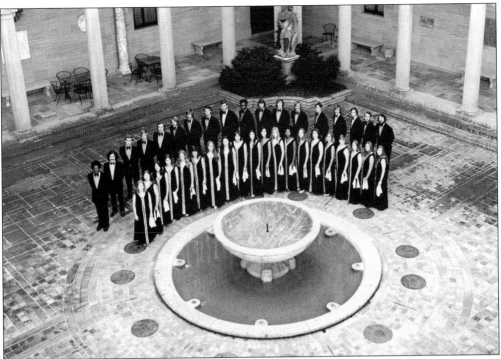

Directed by Eph Ehly, the University of Missouri at Kansas City Conservatory performed at the 1975 national convention in St. Louis.

One of ACDA's legendary choral directors, Eph Ehly served as conductor at the University of Missouri at Kansas City for 27 years. Ehly has performed at three ACDA national conventions, two of which have been with the University of Missouri at Kansas City.

Gordon Lamb (left) interviews Welsh composer William Mathias on March 8, 1975, for *Choral Journal* at the 1975 national convention in St. Louis.

President's Open Letter To the Membership

This issue of the _Choral Journal_ contains historic news. For the first time since the founding of ACDA we are searching for an executive secretary. After twenty years of use it up, make it do, or do without, the man who has supplied leadership continuity for ACDA has announced his intention to vacate the post of Executive Secretary and soon thereafter to retire as Editor of the _Choral Journal_. This has created a severe shock wave throughout the membership. The thought of not having Wayne to call as a handy reference for all association matters is somewhat chilling.

Whom do we turn to? He has served with patience and good humor as father confessor and teacher to all neophyte officers of ACDA and if the officers have functioned well, it has been in part due to Wayne. He has suffered the barbs of criticism as well as the warmth of praise. His kitchen table has been the nerve center for ACDA and his home phone has received or been the originating source for the life and times of ACDA. Sooner or later almost all that was and is ACDA was discussed via that instrument. Through all kinds of activity Wayne has kept us calm, allowed for our private tantrums and our public outbursts. He has found humor in us and allowed us to laugh at our own foibles. Above all else, he has given of himself. His devotion to ACDA has been unswerving. We know that his varied interest will lead him to new things. We also know that while his ties with ACDA may change, they will not be severed. It would be unthinkable to separate Wayne from ACDA. Many of you reading this may well think of it solely as a page of praise to Wayne. That it is, but it is also a list of qualities that have made for a successful Executive Secretary of ACDA. We don't want a duplicate but we hope for the good fortune to have a great Executive Secretary in the line of great ACDA Executive Secretaries.

Your screening committee consists of Colleen Kirk, Chair, Gerry Loper, Nathan Carter, James Kimmel, Charles Hirt, Walter Collins, Morris Hayes, Wayne Hugoboom ex officio, non-voting, and Russell Mathis ex officio, non-voting.

Sincerely,

Russell Mathis

In May 1976, executive secretary R. Wayne Hugoboom announced his retirement. In an open letter to the membership, ACDA president Russell Mathis wrote, "He has served with patience and good humor as father confessor and teacher to all neophyte officers of ACDA and if the officers have functioned well, it has been in part due to Wayne."

ACDA held a special even-year convention in 1976 to commemorate the bicentennial of the United States. The event was held at the National Music Camp in Interlochen, Michigan, and was highlighted by a 200-voice choir comprised of the top vocal quartet from each state. The group performed the premiere of Lukas Foss's *American Cantata*. Gene Brooks was appointed executive secretary of ACDA at the executive committee meeting held during this bicentennial convention. Brooks was to take office on July 1, 1977, when R. Wayne Hugoboom was to retire.

The attendance at the 1977 ACDA National Convention in Dallas had grown to a point where dual-track interest sessions were necessary. It was the first convention where members were on two tracks. From left to right (first row) R. Wayne Hugoboom, Russell Mathis, and unidentified; (second row) Charles Hirt, Jane Skinner Hardester, Royce Saltzman, Walter Collins, and unidentified share a meal together at the Dallas convention.

R. Wayne Hugoboom's last convention was in 1977. The ACDA convention planning committee organized a tribute to Hugoboom at the 1977 national convention, where he was presented a portrait with the inscription "It is with admiration, gratitude and love that the membership of ACDA dedicates this convention to R. Wayne Hugoboom." The portrait was to be hung in the ACDA national office. Hugoboom died less than a month after the convention on April 2, 1977. The officers used the ACDA president's reception at the convention to announce Gene Brooks as Hugoboom's successor. Pictured are Hugoboom (left) and Jim Moore, program chair of the 1977 Dallas convention.

German television recorded some of the 1977 ACDA convention in Dallas, which was later broadcast in Germany. One of the choirs filmed, the Swainsboro Elementary Choir, was the first elementary school choir to sing at an ACDA national convention. This photograph of the Swainsboro Elementary Choir is from an earlier ACDA division convention in 1974.

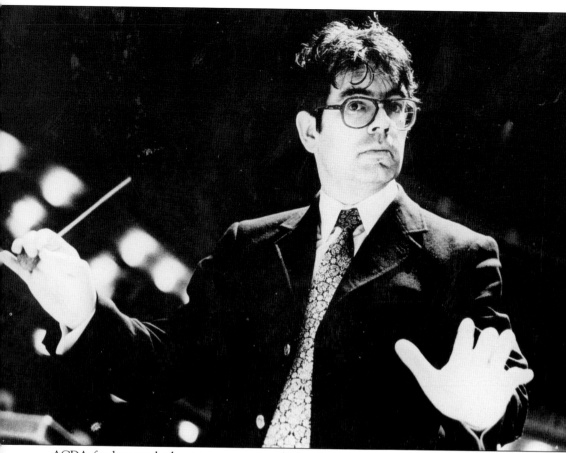

ACDA further reached out to international choral connections in 1977. German conductor Helmuth Rilling was invited to the Dallas national convention to speak about Johann Sebastian Bach's influence on later German composers, and to direct a concert of German choral music at the final concert of the convention. Rilling has distinguished himself with choral directors due to his encyclopedic knowledge and recordings of the works of Bach and other German composers.

With R. Wayne Hugoboom's death, Gene Brooks took office earlier than originally planned. In addition to being executive secretary, Hugoboom had been editor of *Choral Journal*. Before the executive committee approached Brooks about the new position, it determined the bylaws permitted the appointment of two separate people to these positions. It also determined that finding a new home for the national headquarters would be the first priority for the newly appointed executive secretary, and it asked Brooks to begin the search for this location before he officially took office. Brooks was born on June 15, 1936, near Rush Springs, Oklahoma. He attended Cameron College in Lawton, Oklahoma, and then transferred to the University of Oklahoma where he majored in choral music education. He completed his bachelor's degree at Oklahoma Baptist University where he sang in the Bison Men's Glee Club under the direction of Warren Angell. Brooks graduated from Oklahoma Baptist University in the spring of 1959. This picture of Brooks was taken at the family farm near Rush Springs.

AMERICAN CHORAL
DIRECTORS ASSOCIATION

NATIONAL HEADQUARTERS

One of Gene Brooks's first tasks in office was the completion of the sale of the Tampa property and the search for a new ACDA national headquarters. Russell Mathis, ACDA president from 1974 to 1977, suggested the association rent space on the University of Oklahoma campus. Brooks's association with the McMahon Foundation of Lawton, Oklahoma, led him in a different direction. After deciding to approach the McMahon Foundation to request funding for the building of the national headquarters, Brooks contacted John Shoemaker, former superintendent of schools in Lawton and chair of the McMahon Foundation. ACDA was eventually granted $100,000 from the foundation.

With $100,000 from the McMahon Foundation, and with the land secured, bids were solicited for the construction of the national headquarters. A $200,000 building contract was secured that led to the solicitation of the McMahon Foundation for an additional $100,000 toward the project. Construction began in 1977, and the building was completed in September 1978. The building was completely financed by the McMahon Foundation.

The building was furnished with equipment and furniture, and the board room reflects the quality of the organization. The room features a wood-paneled ceiling, stained-glass skylights, pewter chandeliers, entrance doors carved from California hardwood, and an impressive room-length executive board conference table.

The Lawton office was dedicated at the first ACDA summer state presidents' weekend retreat and leadership training conference on Sunday, June 17, 1979. The dedication commemorated the new building as well as the 20th anniversary of ACDA.

The American Choral Directors Association requests the pleasure of your company at the ceremonies celebrating the completion of the National Headquarters building, 502 S.W. Thirty-Eighth Street Lawton, Oklahoma on Sunday, June Seventeenth, Nineteen Hundred Seventy-Nine Tours of the building, from four o'clock to five-thirty.

The dedication ceremony was the climax for the ACDA summer state presidents' weekend retreat and leadership training conference. The highlight of the ceremony was a performance by the Gregg Smith Singers. After the ceremony, David Johnson wrote about the weekend stating, "Only time will evaluate its depth, but all that is inside me indicates 'this is one of the biggies.'"

In this photograph, Doreen Rao works with members of the Glen Ellyn Children's Choir in Glen Ellyn, Illinois. As children's choruses repertoire and standards chair, Rao coordinated the first ACDA National Children's Honor Chorus in 1983 in Nashville. She is part of ACDA's *On Location* video series.

ACDA has had 11 national treasurers since its beginning in 1959. These treasurers are Earl Willhoite (1959–1960), Elwood Keister (1960–1961), David Davenport (1961–1962), J. Clark Rhodes (1962–1964), Harvey Maier (1964–1974), Gene Brooks (1974–1977), Philip Mark (1977–1981), Julie Morgan (1981–1985, 2005–), Robert Snyder (1985–1989), Elaine McNamara (1989–1997), and Maxine Asselin (1997–2005). Philip Mark is pictured above with an unidentified convention attendee at a late-1970s convention.

ACDA conventions are a time for reuniting. ACDA legend Howard Swan and his wife share a conversation with a convention attendee at a late-1970s convention.

Four

COMING OF AGE

The Outstanding Student Chapter Award was established by ACDA in 1978 as a means of recognizing an ACDA student chapter that, through its activities, best supports the advancement of choral music. The award consists of a plaque that becomes the permanent property of the winning chapter and two monetary awards. The first recipient of this award was the Ohio State University, Maurice Casey advisor. The ACDA student chapter of East Carolina University, pictured above and advised by Rhonda Fleming, won the 1981 ACDA Outstanding Student Chapter Award.

American Choral Directors Association

National Convention

Ecumenical Service

Thursday
March 5, 1981
Friday
March 6, 1981
7:00 p.m.
St. Louis Cathedral
New Orleans, Louisiana

The year 1981 was a turning point for ACDA conventions. Instead of using a hotel ballroom as a performance venue, as was past practice, a premier concert hall was used for the first time to host the featured convention performance. At this convention in New Orleans, Robert Shaw conducted the Atlanta Symphony Orchestra and a chorus consisting of various college and university choirs in a performance of Beethoven's *Missa Solemnis*. This convention featured an ecumenical service at the St. Louis Cathedral that set the standard for future such services and is still talked about today. The 1981 New Orleans convention was the first convention attended by doctoral conducting student Tim Sharp, who would become executive director of ACDA in 2008.

Wayne Hugoboom Commission:
1983 ACDA National Honors Children's Chorus

The 1983 ACDA National Honors Children's Chorus will be comprised of 100 treble-voiced children from throughout the United States, selected on the basis of recommendations of their directors. The children will convene in Nashville to rehearse and perform works by di Lasso, Schubert, Kodaly, Faure, and other composers. The closing selection of their performance will be a commissioned work by Michael Hennagin in honor of Wayne R. Hugoboom, ACDA's first and long-time Executive Secretary. Mr. Hennagin's composition will be the first commissioned by the Hugoboom Memorial Fund, which was created by donations in his honor. Commissions from the Fund will be made periodically to reflect Mr. Hugoboom's frequently-expressed enthusiasm for choral compositions in a contemporary vein that are practical for performance by young singers and choirs of average ability. Supervision of the Hugoboom Memorial Fund and the awarding of such commissions is the responsibility of the Past Presidents Advisory Council of ACDA.

Jean Ashworth-Gam, Guest Conductor

Jean Ashworth-Gam is an honor graduate of the University of Toronto and the Royal Conservatory of Music and Founder/Music Director of the award-winning Toronto Children's Chorus, which won first place this past July in the International Eisteddfod Competition in Llangollen, North Wales, over 35 other children's choirs from around the world. She also conducted the Toronto Children's Choir in performances that included Westminster Abbey, Brecon Cathedral, Holy Trinity Church at Stratford-upon-Avon, and the Opening Ceremonies of the Biennial Conference of the International Society for Music Education in Bristol.

Ms. Ashworth-Gam has studied with David Willcocks, Elmer Iseler, and Jon Washburn in the course of developing outstanding choral programs at Howard

Public Schools and Kingsway-Lambton United Church in Toronto. Internationally known as a clinician, lecturer, and guest conductor, visitors come from around the world to visit her programs and observe rehearsals.

Michael Hennagin

Michael Hennagin is a noted American composer who graduated from the Curtis Institute of Music in Philadelphia, and has studied with Aaron Copland at the Berkshire Music Center, Darius Milhaud at the Aspen Music School, and Leonard Stein in Los Angeles. The recipient of numerous awards and commissions, Mr. Hennagin's music is performed throughout the United States and abroad.

Michael Hennagin has composed in virtually all media, including music for television, motion pictures, as well as incidental music for legitimate stage productions in New York City and Los Angeles. He appears frequently throughout the United States as a guest composer, conductor, and speaker.

Make Plans To Attend The 1983 ACDA National Convention Pre-Register!

This special session will deal with the history and performance of Afro-American folk songs and will be led by the inimitable Jester Hairston, assisted by the University of Mississippi Concert Singers under the direction of Jerry Jordan and the Kentucky State University Concert Choir under the direction of Carl H. Smith.

Jester Hairston

In 1936 Jester Hairston left the world of show business in New York and came to Hollywood as the assistant conductor of the famous Hall Johnson Negro Choir. Hall Johnson was ill during the filming of *Lost Horizons*, and Hairston took over the responsibilities of training the choir and arranging the choral music, which had been composed by the late Dimitri Tiomkin. The result was a success, and Hairston became Tiomkin's choral arranger in films for the next twenty years, collaborating on *Land of the Pharoahs, Duel in the Sun, The Long Night, Red River,* and many others.

In 1949 Hairston became one of the arrangers for the late Walter Schumann Choir of Hollywood, and it was during his work with that organization that his Afro-American folk song arrangements began to attract the attention of choirs from all over the United States. In 1961 the State Department began to send Hairston abroad annually as a good-will ambassador. He holds honorary doctorates from the University of the Pacific (Stockton, CA), Tufts University (Boston, MA), the University of Massachusetts (Amherst, MA), and Luther College (Decorah, IA). At 81, Jester Hairston is still in constant demand as a conductor, clinician, and lecturer.

The year 1983 marked another milestone in ACDA convention history. The first children's honor choir performed at this event in Nashville. It sang the first commission, "I Think I Could Turn" by Michael Hennagin, that had been established in former executive secretary R. Wayne Hugoboom's memory. Hugoboom envisioned a "series of choral works by ACDA composers for all levels of activity and proficiency from Children's choirs to High School, Church and Community groups." Doreen Rao, children's choruses repertoire and standards chair, coordinated the session, and Jean Ashworth-Gam (Bartle) conducted.

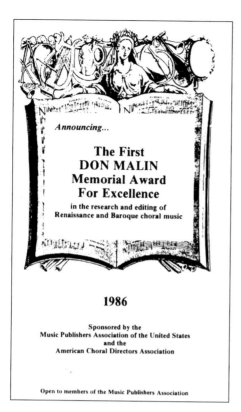

Announcing...

**The First
DON MALIN
Memorial Award
For Excellence**

in the research and editing of
Renaissance and Baroque choral music

1986

Sponsored by the
Music Publishers Association of the United States
and the
American Choral Directors Association

Open to members of the Music Publishers Association

ACDA has had a history of honoring those who have made special contributions to the organization. Don Malin has been both a recipient, and has had an award named for him. Malin was ACDA's first industry representative from 1964 to 1966. In 1975, he was given an industry special service award at the ACDA national convention in St. Louis for his service. The Don Malin Award was begun in 1986 for excellence in research and editing in contemporary performing editions of Renaissance and baroque choral music.

Colleen Kirk, ACDA national president from 1981 to 1983, spent much of the decade of the 1980s restructuring the national repertoire and standards committee and formalizing ACDA's present organizational structure. Through Colleen Kirk's efforts, the stage was set for national repertoire and standards committee chairs Sr. Sharon Breden, Barbara Tagg, and Nancy Cox to implement the repertoire and standards leadership structure throughout ACDA at national, division, and state levels.

Dedication Weekend of the
American Choral Directors Association
National Headquarters
502 Southwest Thirty-eighth Street
May 30-31, 1987
Lawton, Oklahoma

Between 1978 and 1988, ACDA membership doubled in size from 8,000 to 16,000. As the membership grew, so did the needs of the blossoming association. To meet the growing demands, Gene Brooks approached the McMahon Foundation on September 1, 1983, for additional funding for the expansion to the Lawton building. After a season of negotiation, the foundation approved a $100,000 grant for this purpose.

The expansion included two offices, reception area, library, reading room, storage room, and archival storage space, connecting to the original building. Construction took place between August 1985 and March 1986. The dedication of the space took place on May 30, 1987, with the United States Soldier's Chorus from Washington, D.C, performing. Pictured is the exterior of the 1986 addition to the Lawton headquarters.

In the early to mid-1980s, discussion took place regarding the possibility of starting an ACDA endowment. It was the desire of the officers to create an endowment to fund special projects and provide the membership an opportunity to contribute to the organization for scholarships and awards. Gene Brooks had met Raymond Brock (pictured) while adjudicating a festival in South Carolina. Brock, an ordained Methodist minister, had a particular love for choral music. Brooks asked Brock to create and develop the endowment fund. With Brock's business acumen and passion for the choral art, he was successful in starting the endowment initiative.

Brock was responsible for resurrecting *Leadership Interchange*, a newsletter that Colleen Kirk had successfully distributed to ACDA leadership during the 1980s. Seen here is a draft of Brock's first *Leadership Interchange*.

US ISSN 0009-5028
JUNE 1984

THE CHORAL JOURNAL

Official Publication of the AMERICAN CHORAL DIRECTORS ASSOCIATION

A sign of growth and the coming of age of ACDA was the addition of a 10th publication month to the formerly nine-month *Choral Journal* cycle in 1984. This cycle was increased to 12 issues in 2005 and then modified in the summer of 2008 by combining the June and July issues into one publication. Further, in 1989 during a business meeting at the Louisville national convention, ACDA leadership discussed and voted to change the title of the executive secretary to executive director.

The ACDA National Endowment was established with its own independent set of bylaws, connected but still separate from ACDA. From its initiation in 1987 to May 1988, the endowment had accumulated approximately $41,580 in pledges. By 1997, the endowment provided award money for the biennial student conducting competition and supported choral composers through the Raymond W. Brock Memorial fund. Other smaller award accounts were created including the Colleen Kirk, Allen Lannom, Charles C. Hirt, and James Mulholland Awards, in support of student choral musicians and doctoral studies.

Continuing ACDA's tradition of honoring those who had served the association, ACDA honored its *Choral Journal* editors at the 1989 Louisville national convention. *Choral Journal* editors have included R. Wayne Hugoboom, 1959–1970; Allen Lannom, 1970–1972; Raymond Moremen, 1972–1974; Louis Diercks, 1974–1978; Jack Boyd, 1978–1981; James McCray, 1981–1983; Lynn Whitten, 1983–1985; Wesley Coffman, 1985–1989 and 1998–1999; Dennis Shrock, 1989–1992; John Silantien, 1992–1998; and Carroll Gonzo, 1999 to present. Tim Sharp, ACDA's executive director, joined the *Choral Journal* editorial board in 1990. Pictured above, from left to right, are Lannon, Coffman, McCray, Boyd, and Whitten.

Five

ASSETS, AWARENESS, AND ADVOCACY

Raymond Brock, ACDA's director of development, died on August 12, 1991. During his days in the hospital, he expressed an interest in having any memorials in his honor to be used to develop a fund that would lead to the commissioning of new choral works. At Brock's funeral, Theron Kirk arranged a setting of "O for a Thousand Tongues" which was performed by members of ACDA from across the United States. It was directed by Larry Wyatt from the University of South Carolina.

After Brock's death, the endowment received contributions between $5,000 and $6,000. Within months of Brock's passing and upon the encouragement of Gene Brooks to the ACDA membership, contributions to the Raymond W. Brock Memorial account grew to approximately $70,000. To maintain Brock's wish for the support of new American choral composition, the endowment board of trustees voted to establish the Raymond W. Brock Memorial account as a separate account within the ACDA endowment. By the end of 1991, the ACDA endowment had established a board of directors to disburse the endowment assets. Members of the endowment board met at Maurice Casey's Montana retreat in 1994. Pictured are, clockwise from bottom left, Mrs. Louis Batson, Josephine Abney, Gene Brooks, Jane Casey, Maurice Casey, Maxine Asselin, and Louis Batson.

As the Raymond W. Brock commission developed in scope, the endowment board of trustees created additional guidelines for the selection of the Brock commission. The music was to be substantial yet accessible to ensure that the piece would be long-lived. Also, the selected composer was to be a well-known and respected contributor to the compositional field. Further, it was decided that the Brock commissions should be performed at both national and divisional conventions.

To Gene Brooks-
with continuing appreciation for his confidence in me, his generosity and, not least of all, for his gentle persistence from his friend,

CARLISLE FLOYD Carlisle Floyd
March '97

A TIME TO DANCE

Reflections on Mortality

A Cycle of Ten Songs with Preamble
for Mixed Chorus, Bass-baritone Soloist and Orchestra
on Texts of English and American Poets

Piano Vocal Score

BOOSEY & HAWKES

AMERICAN CHORAL DIRECTORS ASSOCIATION

Raymond W. Brock Endowment Trust
Commissioned Choral Compositions

Volume One

Adler
Aitken
Brunner
Gawthrop
Hailstork
Kirk
Mulhollan
Paulus
Pinkham
Pinkston
Walker

Raymond W. Brock

Brock commission composers have included prestigious American choral composers Carlisle Floyd, Daniel Gawthrop, James Mulholland, Daniel Pinkham, Eric Whitacre, Steven Paulus, Samuel Adler, Adolphus Hailstork, Gwyneth Walker, David Brunner, Richard Nance, Rene Clausen, Z. Randall Stroope, Gian Carlo Menotti, Morten Lauridsen, Mack Wilberg, David Conte, Eleanor Daley, and Dominick Argento. In 1997, ACDA established the Raymond W. Brock Memorial Student Composition Competition. The winner receives a cash prize, convention registration, and the performance of their choral composition at an ACDA convention.

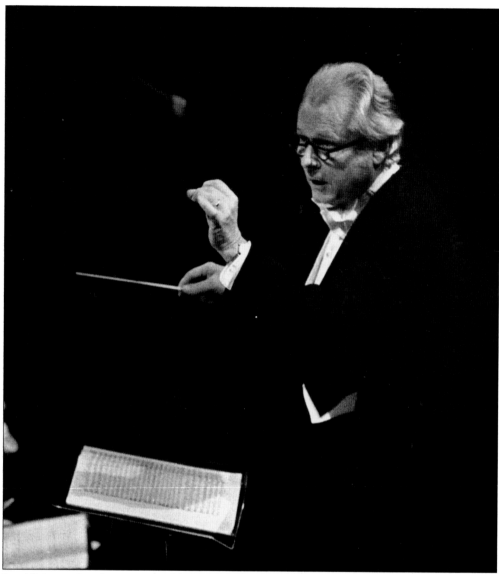

In addition to the advancement of American choral composition and student choral composition, the ACDA endowment also provides awards in the areas of student conducting competition (established in 1993 and awarding first- and second-place prizes to undergraduate and graduate competitors), scholarships for younger ACDA members to attend ACDA division conventions, and the support of doctoral students in choral conducting. The awards are established in the names of Colleen Kirk, Allen Lannom (pictured), and Robert and Donna Watkins.

In the late 1970s, the Julius Herford Prize was established by Walter Collins and the ACDA Research and Publications Committee to honor and recognize the best dissertation written on a choral music topic. Additional ACDA national awards include the State Newsletter Award and the Robert Shaw Award, given to the choral leader who has made significant contributions to the art of choral music. In 1990, a graduate fellowship/research grant program was established to provide students with funding for their research projects.

To maintain the expanding archives of ACDA, Marion Donaldson was added to the national headquarters staff in March 1992. She took over for ACDA's volunteer archivist, past president Walter Collins. The growing collections bequeathed to ACDA included materials given by Fred Waring, Elaine Brown, Ferenc Farkas, Harold Decker, Charles C. Hirt, Morris Hayes, Elwood Keister, Russell Mathis, and others. In addition, contributions of recordings, scrapbooks, photographs, and a variety of records and correspondence have been accumulated by ACDA. The expansion allowed for the further study of the history of American choral music. Pictured are, from left to right, archives committee members Wesley Coffman, Marion Donaldson, and Conan Castle at the 1997 leadership conference in Lawton, Oklahoma.

FROM THE EXECUTIVE DIRECTOR

A Special Thanks to the Divisions

I WANT TO THANK all the divisions for putting together outstanding conventions this past February and March. Each of the Division Convention Planning Committees demonstrated outstanding organization and development of excellent concert programs, thus ensuring that all the conventions were truly successful events for ACDA members. Several of the conventions even saw record attendance.

Each of the choirs performed at their level best (I continue to be amazed at how much performing groups improve through the years). In addition, the clinicians who shared their knowledge at the various interest sessions showed the high level of expertise we have come to expect from those in our profession.

Finally, I wish to extend my appreciation to the exhibitors who set up their booths in the exhibit halls. During the years, they have added so much to the organization through the various services they provide ACDA membership. Their presence at ACDA conventions makes attending these events a complete experience.

ACDA's Resolve to Advocacy

Finally, please read ACDA's resolution statement, printed below, regarding arts advocacy. ACDA encourages all its members to reprint this statement in concert programs so that we as choral directors may increase public awareness of choral music's vital role in society. I also encourage you to read the Strategic Plan (page 39 of this issue) about ACDA's efforts at stronger advocacy on behalf of the choral art.

Gene Brooks

ACDA Advocacy Resolution

Whereas the human spirit is elevated to a broader understanding of itself through study and performance in the aesthetic arts; and

Whereas serious cutbacks in funding and support have steadily eroded state institutions and their programs throughout our country;

Be it resolved that all citizens of the United States actively voice their affirmative and collective support for necessary funding at the local, state, and national levels of education and government, to ensure the survival of arts programs for this and future generations.

ACDA members are encouraged to print the ACDA Advocacy Resolution on all concert programs.

STATEMENT OF MEMBERSHIP
The American Choral Directors Association is a nonprofit professional organization of choral directors from schools, colleges, and universities; community, church, and professional choral ensembles; and industry and institutional organizations. *Choral Journal* circulation: 17,000. Annual dues (includes subscription to the *Choral Journal*): Active $45, Industry $100, Institutional $75, Retired $17.50, and Student $15. One-year membership begins on date of dues acceptance. Library annual subscription rates: U.S. $25; Canada $35; Foreign Surface $38; Foreign Air $75. Single Copy $3; Back Issues $4.

ACDA is a founding member of the International Federation for Choral Music. ACDA supports and endorses the goals and purposes of Chorus America in promoting the excellence of choral music throughout the world.

ACDA reserves the right to approve any applications for appearance and to edit all materials proposed for distribution. Permission is granted to all ACDA members to reproduce articles from the *Choral Journal* for noncommercial, educational purposes only. Nonmembers wishing to reproduce articles may request permission by writing to ACDA.

The *Choral Journal* is supported in part by a grant from the National Endowment for the Arts, a federal agency.

Recognizing its position of leadership, ACDA complies with the copyright laws of the United States. Compliance with these laws is a condition of participation by clinicians and performing groups at ACDA meetings and conventions.

© 1994 by the American Choral Directors Association, 502 SW Thirty-eighth Street, Lawton, Oklahoma 73505. Telephone: 405/355-8161. All rights reserved. The *Choral Journal* (US ISSN 0009-5028) is issued monthly, except for June and July. Printed in the United States of America.

Application to mail at second-class postage is paid at Lawton, Oklahoma, and additional mailing office. POSTMASTER: Send address changes to *Choral Journal*, Post Office Box 6310, Lawton, Oklahoma 73506-0310.

AFFILIATED ORGANIZATIONS

INDIANA CHORAL DIRECTORS ASSOCIATION
President - Barbara J. Waite
554 South Ruston Avenue
Evansville, Indiana 47714
Treasurer - Paula J. Alles
1471 Altmeyer Road
Jasper, Indiana 47546

IOWA CHORAL DIRECTORS ASSOCIATION
President - Robert G. Youngquist
831 South Thirteenth Avenue
Washington, Iowa 52353
Secretary/Treasurer - Bruce A. Norris
420 Maple Street
Mondamin, Iowa 51557

MINNESOTA CHORAL DIRECTORS ASSOCIATION
President - Michael Smith
Brainerd High School, 702 South Fifth Street
Brainerd, Minnesota 56401
Treasurer - Richard Edstrom
2305 Winfield Avenue, North
Golden Valley, Minnesota 55422

MONTANA CHORAL DIRECTORS ASSOCIATION
President - Norbert Rossi
Post Office Box 1884
Columbia Falls, Montana 59912
Treasurer - John Haughey
2126 Northridge Circle
Billings, Montana 59102

NEBRASKA CHORAL DIRECTORS ASSOCIATION
President - Richard Palmer
Dana College
Music Department
2900 College Drive
Blaire, Nebraska 68008
Treasurer - Clark Roush
York College
York, Nebraska 68467

OHIO CHORAL DIRECTORS ASSOCIATION
President - James S. Gallagher
School of Music, Ohio State University
1866 College Road
Columbus, Ohio 43210
Treasurer - Herb Henke
Oberlin Conservatory
Oberlin, Ohio 44074

TEXAS CHORAL DIRECTORS ASSOCIATION
President - Debbie Helm
601 Shady Creek Trail
Mesquite, Texas 75150
Secretary/Treasurer - Marsha Carlisle
1308 Northpoint Drive, South
San Marcos, Texas 78666

WISCONSIN CHORAL DIRECTORS ASSOCIATION
President - Gregory R. Carpenter
1604 Cottonwood Drive
Waukesha, Wisconsin 53186
Secretary/Treasurer - William Ross
814 West Larabee Street
Port Washington, Wisconsin 53074

In 1993, ACDA president William Hatcher led ACDA to develop its arts advocacy resolution, which was to appear in all of ACDA's printed publications. The statement, written by Bruce Becker with input by Diana Leland, was designed to create awareness for the need for arts funding and arts advocacy at all levels of arts creation and experience. The statement was approved in February 1994 and first appeared in the May 1994 *Choral Journal*. The statement reads: "Whereas the human spirit is elevated to a broader understanding of itself through study and performance in the aesthetic arts; and whereas serious cutbacks in funding and support have steadily eroded state institutions and their programs throughout our country; Be it resolved that all citizens of the United States actively voice their affirmative and collective support for necessary funding at the local, state, and national levels of education and government, to ensure the survival of arts programs for this and future generations."

111

In 1993, the McMahon Foundation of Lawton, Oklahoma, granted ACDA $15,000 to help fund the biennial national leadership conference for all ACDA state, division, and national officers. The conference was held on August 11–16, 1993, to help newly elected officers of ACDA. During the course of the conference, officers conveyed leadership information on all topics related to choral music. The conferences have continued on a two-year interval. They were held in Lawton until 2005 when they moved to Oklahoma City.

Six

THE THIRD GENERATION

ACDA national presidents have all worked to uphold the purposes of the founders. Once every two years, they meet at the national convention. This picture from 2001 includes, from left to right, (first row) Maurice Casey, David Thorsen, Diana Leland, Warner Imig, and Jim Moore; (second row) William Hatcher, Royce Saltzman, Russell Mathis, Harold Decker, and John Haberlen. Additional ACDA national presidents not pictured in this photograph are Archie Jones, Elwood Keister, J. Clark Rhodes, Theron Kirk, Charles C. Hirt, Morris D. Hayes, Walter Collins, Colleen Kirk, Hugh Sanders, Lynn Whitten, Milburn Price, David Stutzenberger, Mitzi Groom, Michele Holt, Hilary Apfelstadt, and Jerry McCoy.

American Choral Directors Association
A New Neighbor on the Block in OKC

By Linda Bosteels
Director of Marketing and Public Relations,
Canterbury Choral Society

This month, Linda Bosteels visits with Dr. Gene Brooks, the Executive Director of the American Choral Directors Association (ACDA), which has recently relocated their archives, the McMahon International Choral Museum and the Choral Journal offices from Lawton to Oklahoma City. The following is an interview about ACDA with Dr. Brooks.

By the late 1990s, ACDA's professional staff began to realize the need to move ACDA's national headquarters to a larger city. Oklahoma City was the practical and opportunistic choice. Oklahoma City's downtown renaissance was compelling. Other deciding factors included the convenience of a major airport, as well as incentives and concessions offered by Oklahoma City leadership to bring the national headquarters to the state capital.

In the late 1990s, ACDA made plans for a world choral music communication and resource center and historical museum of American choral music. The McMahon Foundation gave ACDA $300,000 toward these two projects with the stipulation that ACDA generate $200,000 in matching funds. The match was secured by a $10 increase in membership dues. The funds were successfully raised, which resulted in the McMahon International Choral Music Museum, located in the ACDA headquarters building in Oklahoma City. The museum was dedicated in August 2004.

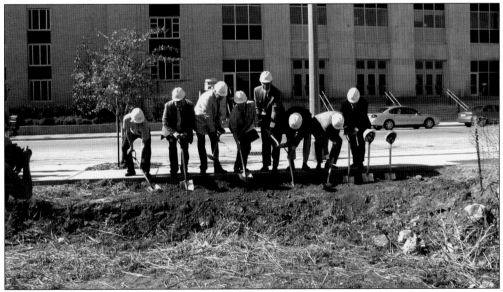

Gene Brooks approached Oklahoma City mayor Kirk Humphreys about the possibility of moving ACDA's headquarters to the arts district in downtown Oklahoma City. A location across the street from the newly-renovated civic center was identified and ACDA was offered the property. The decision was made at the 2001 leadership conference by the ACDA national board of directors to begin the construction of the new ACDA facilities in Oklahoma City. The groundbreaking took place on July 31, 2002.

Construction of the new ACDA Oklahoma City building began in August 2002. Architect Bill Howard planned a two-story building of 12,500 square feet, with museum space attached to the office space. Building took more than a year, and the relocation of the national headquarters occurred over the summer, fall, and winter of 2003 with a final move-in date of January 2004. The building was formally dedicated on August 4, 2004, at the ACDA national board meeting.

After the move of ACDA's national headquarters to Oklahoma City, the national staff of ACDA expanded to meet the needs of the mature association. Staff positions included receptionist, administrative assistant, division liaison and convention consultant, director of membership services, *Choral Journal* editor, *Choral Journal* managing editor, *Choral Journal* assistant editor, director of information technology, national accountant, division accountant, associate director and legal counsel, archivist, and executive director.

In 2006, Christina Prucha joined the ACDA national headquarters staff as the association's first full-time archivist, providing professional guidance for the development of the McMahon International Choral Music Museum. Prucha's academic preparation in the area of library science and research as well as her understanding of the work of ACDA were well-suited to the tasks of building the archive and museum programs in their new location in Oklahoma City. The transition of the archives from Lawton to Oklahoma City was completed in the summer of 2008. The new museum opened officially to the public for the first time on March 4, 2009.

McMAHON INTERNATIONAL CHORAL MUSIC MUSEU
HOWARD AND ASSOCIATES ARCHITECTS

Today's archives continue to advance the research mission of ACDA and support the original purpose statement. Goals for the ACDA archives include the full development of the McMahon International Choral Music Museum as a destination for choral enthusiasts and researchers, as well as an educational center, the opening of the archives to researchers from around the world, the ongoing cataloging of the historical holdings of ACDA and special collections acquired over its history, and the serving of the choral research needs of the membership.

Gene Brooks, executive director of ACDA since 1977, died on July 21, 2007. Under Brooks's leadership, the association grew to a membership of 21,000. He guided the move and building of ACDA's headquarters in both Lawton and Oklahoma City and the maturation of the association's offering of national and division conventions. He guided the birth of ACDA's endowment and helped to structure the awards and recognitions administered by the endowment.

In August 2007, Jerry Warren was appointed interim executive director of ACDA, serving through April 2008. Warren had served ACDA as Southern Division president as well as being an active choral conductor in Nashville, Tennessee. Warren brought a vast amount of administrative experience to ACDA in this interim, as well as a lifetime of service to ACDA as a member and state and division leader. His love for and service to ACDA combined with his adroit leadership skills served ACDA in an exceptional manner during the period following the long career of Gene Brooks.

An executive director search committee chaired by past president Milburn Price was appointed in the fall of 2007 to fill this strategic position. The search culminated with the appointment of Tim Sharp, who took office on May 1, 2008. Sharp came to ACDA from the position of dean of fine arts at Rhodes College in Memphis, Tennessee, where he also conducted the college choirs. He had previously served as director of choral activities at Belmont University in Nashville, Tennessee. Having been an ACDA member in three ACDA divisions as well as serving on the *Choral Journal* editorial board for 18 years, he brought an intimate perspective to the position.

The Purposes of ACDA

To foster and promote choral singing which will provide artistic, cultural, and spiritual experiences for the participants.

To foster and promote the finest types of choral music to make these experiences possible.

To foster and promote the organization and development of choral groups of all types in schools and colleges.

To foster and promote the development of choral music in the church and synagogue.

To foster and promote the organization and development of choral societies in cities and communities.

To foster and promote the understanding of choral music as an important medium of contemporary artistic expression.

To foster and promote significant research in the field of choral music.

To foster and encourage choral composition of superior quality.

To foster and promote International exchange programs involving performing groups, conductors, and composers.

To foster and encourage rehearsal procedures conductive to attaining the highest possible level of musicianship and artistic performance.

To cooperate with all organizations dedicated to the development of musical culture in America.

To disseminate professional news and information about choral music.

— ACDA Constitution and Bylaws

As ACDA enters the 21st century, new challenges and opportunities await a third generation of ACDA and its emerging new choral directors. Executive director Tim Sharp outlined new initiatives for ACDA built upon the foundations and professional advancements of ACDA's pioneers. The purposes adopted by ACDA in 1959 remain as valid and substantial today as they were 50 years ago, but new expressions and interpretations offer new directions.

Within his first 90 days in office, Tim Sharp led ACDA in a complete redesign of its Web site. Sharp had signaled his technological intentions before taking office in an initiative announced to the membership: "I envision a twenty-first century ACDA that utilizes the full extent of technological communication and other technologies for the benefit of our membership." ACDA quickly acquired the domain Web address www.acda.org (it had been established earlier as www.acdaonline.org) and worked on a number of fast-paced innovations that led ACDA to become a data-driven association.

ACDA celebrated its 50th anniversary on March 4–7, 2009, just weeks after the United States inaugurated its 44th president. Education is one of the challenges facing the country in 2009 with revisions and ongoing attention required for strengthening arts education through the No Child Left Behind Act of 2001. ACDA's executive director challenged ACDA to consider a vision for its work toward building opportunities for every child in the country to be able to sing in a choir. Such an initiative requires new levels of collaboration and effort on the part of ACDA's creative and capable membership. Collaborations such as those created between ACDA and Americans for the Arts will help advance this initiative. Pictured above is the Chevy Chase Elementary School Chorus with Joan Gregoryk as the conductor.

Another initiative outlined for ACDA as it moves forward is for the association to become fully engaged in world choral initiatives. ACDA's forward-thinking leadership founded the International Federation for Choral Music (IFCM) in 1982, where ACDA maintains its position as a founding board member. IFCM has matured to become a significant international choral facilitator, led by president Lupwishi Mbuyamba of Mozambique. Currently, ACDA is further represented on the IFCM executive committee through ACDA members Michael J. Anderson, IFCM first vice president, and Philip Brunelle, IFCM treasurer. As borders have eroded and new partnerships forged worldwide, ACDA is poised to take full advantage of the benefits of world choral connections and relationships. Conductor exchange programs, international symposia and festivals, new tour destinations, world choral commissions, and a long list of new international choral initiatives await full engagement by ACDA's membership. Pictured above is the Indonesian Children's and Youth Choir, which participated in the international choirs night at the 2007 Miami convention. It was conducted by Aida Simanjuntak Swenson.

ACDA's research and publications committee worked diligently toward a collaboration that led to the establishment of a Web site with the Library of Congress. This collaboration offers public domain choral scores from the collection of 19th-century sheet music for downloading. Research and publications committee chair William Belan, director of choral studies at California State University, Los Angeles, originated the idea and along with committee member John Silantien and former research and publications chairs Joan Conlon and Don Oglesby advanced the cause during their years as committee chair. On August 8, 2007, ACDA president Hilary Apfelstadt and Library of Congress Music Division head Susan Vita signed the agreement in Washington, D.C., culminating years of development by ACDA's research and publications committee. ACDA's rich archival collection and recently opened McMahon International Choral Music Museum prepare the way for a new research agenda for American choral music. These advancements signal a new era of research and publication at the national level for ACDA, as does Tim Sharp's fourth initiative for ACDA in the 21st century: "I envision a twenty-first century ACDA that sets the research and publication agenda for the best thinking, past and present, in choral music." Pictured are, from left to right, (first row) Hilary Apfelstadt, William Belan, and Karen Moses; (second row) Susan Vita and John Silantien.

BIBLIOGRAPHY

DeJournett, Ned Russell. "The History and Development of the American Choral Directors Association 1957–1970." Ph.D. diss., Florida State University, 1970.

Zamer, Craig. "Gene Brooks and His Contributions to the American Choral Directors Association." Ph.D. diss., Florida State University, 2007.

ACROSS AMERICA, PEOPLE ARE DISCOVERING SOMETHING WONDERFUL. *THEIR HERITAGE.*

Arcadia Publishing is the leading local history publisher in the United States. With more than 3,000 titles in print and hundreds of new titles released every year, Arcadia has extensive specialized experience chronicling the history of communities and celebrating America's hidden stories, bringing to life the people, places, and events from the past. To discover the history of other communities across the nation, please visit:

www.arcadiapublishing.com

Customized search tools allow you to find regional history books about the town where you grew up, the cities where your friends and family live, the town where your parents met, or even that retirement spot you've been dreaming about.